Starstruck

Starstruck

Photographs from a fan
Gary Lee Boas
foreword by Michael Musto
essay by Carlo McCormick

Starstruck
Photographs from a fan
by Gary Boas

Published by
Dilettante Press
P.O. Box 292530
Los Angeles, CA 90029
email: info@dilettantepress.com
www.dilettantepress.com

For Dilettante:
Publisher: Steven R. Najeba
Editor: Jodi Wille
Photo-Editor: Hedi El Kholti with Gary Boas
Book Design: Nick Rubenstein

10 9 8 7 6 5 4 3 2 1

Printed and bound in China through
Palace Press International

Available Through:
DAP/Distributed Art Publishers
155 6th Avenue, 2nd Floor
New York, NY 10013
tel 212.627.1999 fax 212.627.9484
1-800-338-BOOK
www.artbook.com

Boas, Gary
Starstruck : photographs from a fan / Gary Boas ;
foreword by Michael Musto ; essay by Carlo
McCormick. -- 1st ed.
p. cm.
Includes index.
LCCN: 99-74134
ISBN: 0-9664272-5-4

1. Portrait photography. 2. Celebrities--
United States--Portraits. I. McCormick, Carlo
II. Title.

TR680.B63 1999 779'.2
 QBI99-849

[r→l]**Robert Goulet**
at the *United Fund Drive*
General Hospital, Lancaster, PA
Monday, September 12th, 1966

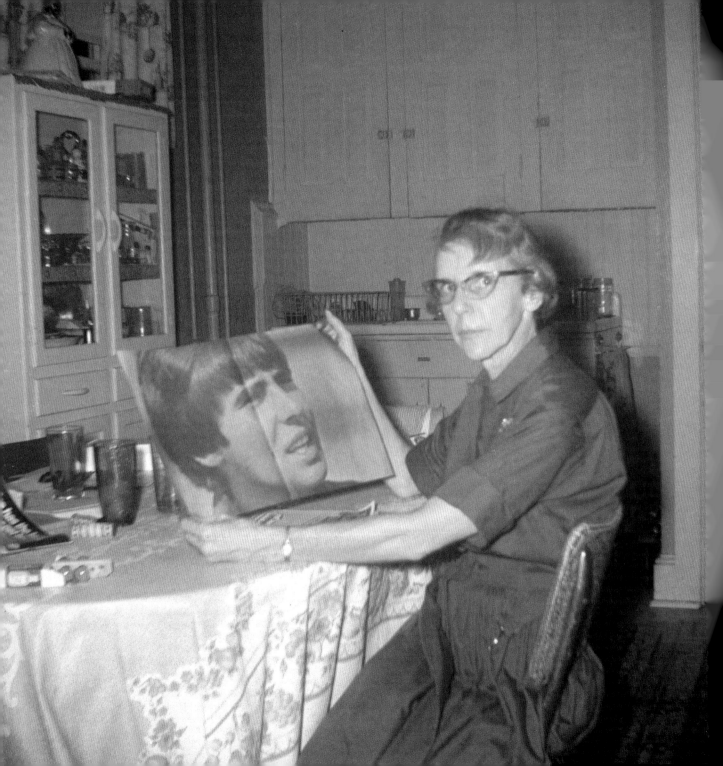

This book is dedicated to two very important people in my life:

First, my mother, Mary, who passed away at the young age of fifty-nine in 1977. She would be so thrilled about this book. My mom was more than a mother; she was my friend and a friend to everyone I knew. I owe her more than I could ever put into words. I could go on and on and really never tell you what she has meant to me. Bless you, Mom, for being there for me and just being you. I miss you. Until we meet again, this one's for you. May you never walk alone!

The other person has been a great friend of mine for more than twenty-eight years: Jeff Wieler. He has been the wind beneath my wings many times. For many years he put up with my craziness, and he came along for many of the photos in this book. He will always be a soul friend to me, and I thank him for all the help, support, and love a friend could give. Jeff, you will always be near to me.

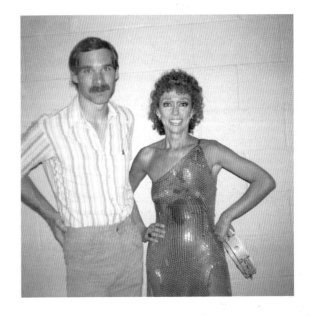

I must extend a very special thanks to four women who made this hobby very worthwhile, and who I am very proud to call my friends: Geraldine Page, Katharine Hepburn, Chita Rivera, and Julie Christie. Thanks to all my friends and the photographers and fellow collectors who have helped me over the years. Also, thanks to Walter McBride, who made me feel that my work was worth putting into print and who got me a job with Retna. Thank you.

At this time I would like to remember friends who met a young and untimely death. I miss you all!

Roy Nash	Dan Schock	Randy Souders
Scott Weaver	Joe Leafeaver	Mark Turner
Jeff Landis	Jeff Smoker	Wayne Sheldon
Carol Pape	Chuck Lyons	Cliff Lowe
Pam Kendall	Tom Gottchell	Marc Stevens
Peggy Kendall	Tom Donovan	Tom Durrell
Robert Kingston	Richard Kline	Jeff Johnson
Wayne Facemyer	Eddie Myers	Chuck Kessler
Vince Mandeville	Rich Scione	Gregg Williams
Robert Keilt	Sam Barringer	Steve Pritz
William "Gil" Shutt	Carl Caskey	*and to my pets:*
Jeff Kreitz	George Cunningham	Blackie, Sophie, and Farter

foreword

I'm a reasonably sophisticated individual, but put me in the same room as one of my idols—say, Diana Ross, David Bowie, or even Patty Duke—and I get all tongue-tied and wobbly-kneed. It's a really sorry spectacle to behold—a grown man reverting to his monosyllabic inner child and stammering out "D, D, Diana Ross is over there!" as if everyone else hadn't already noticed and moved on. But the fact is that, like a lot of perfectly intelligent people, I happen to be completely starstruck. I love celebrities. I'm a fan.

Fortunately, my job as an entertainment columnist enables me to be in the same room with these demigods about six nights a week (on the seventh day, I just watch their movies). Gaining such proximity, I can convince myself that I've finally risen above my social niche from junior high school, when only the dregs would talk to me, and only if they needed something. Now I'm gabbing with Lisa Kudrow, hanging with Marilyn Manson, debating with Cameron Diaz, and stammering the whole time. I'm really fabulous, and even if the celebs are only going along with this because it's their job, I'm still catching some of their residual glitter thanks to amazing way celebrity has of rubbing off. Take a picture—even only a mental one—of a Liz Taylor, and you feel slightly elevated. Say hi to Madonna and the whole world wants to say hello back!

And once you've started following celebrities, just try and stop—there's always a new batch to chase with all new residual glitter, and your appetite becomes more hysteria-laden with each generation. Celebs are so addictive to be around because they've signed an unwritten agreement that they will always act out on a larger, more glamorous scale than ordinary folks. They perform for the camera and, like sea monkeys who vivify in water, come alive at the moment a fan says "I love you!" These people adore being stars as much as we love watching them do so, and this celebrity-fan dance keeps both of us feeling validated—especially since it's performed from an imposed distance that keeps things mysterious enough to stay interesting.

Adding to their allure, celebrities provide imaginary friends for us—personalities whose images we can turn to for comfort, and who—if they disappoint us—can always woo us back via apology and redemption. Don't tell anyone, but a new hairstyle (even if it's just a wig) for Cher can brighten my whole day. What's more, if she ever somehow *sours* my life—by being mean to Chastity, let's say—I have every confidence that the two of them will patch things up, and probably on Oprah. This calculated hatchet-burying is the kind of shameless spectacle I live for, giving me a keyhole glimpse into my fave public figures' supposedly private transactions. And it all ends happily because, once I've forgiven Cher, I don't have to lose her as a friend.

Of course with massive exposure on innumerable TV channels, our celebrity pals don't trek out to visit us as much anymore—they get more bang with just one sound bite on *E.T.* than in a year of doing *Hello, Dolly!* in Pittsburgh—so it's harder to get a live peek at them than back in the '60s. But for those willing to stand poised behind barricades, there's still plenty of selective ogling to be had. Before you wrap your instamatic around your neck like a talisman, though, repeat three times: "There's an art to being a fan." Take great pains to not embarrass either your idol or yourself. Be aggressive but not annoying; complimentary but not effusive. If you actually get to interact with a star, try to say something they haven't heard before—like how you loved them on a *Columbo* episode they might not even remember having done—and take in their response by smiling appreciatively while acting as if you really understand what they're saying. Or just stand back and glow nobly as a security guard tells you to get the fuck away. Either way, don't expect to get a glimpse of the real person—that's not what you're there for anyway. You want the star—and in many cases that's *become* the real person.

It's all so much fun, when done properly, that I'm stammering and wobbling just thinking about it. And though I often end up dishing out some extremely hostile observations about these folks, I still want desperately to be near them. I long to get a vicarious thrill out of their sparkle while not having to assume any of the hideous pitfalls that come with it. Thank you, celebrities. Now, say "Cheese"!

—Michael Musto
New York City
May 1999

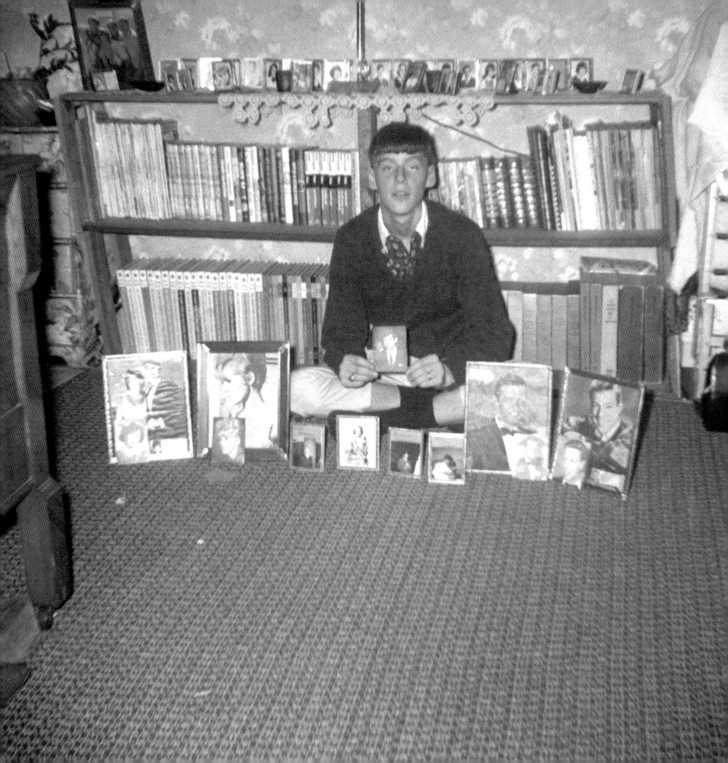

introduction

Back in the sixties and seventies, ballplayers sold insurance or shook hands at the local steakhouse in the off-season to make ends meet. Broadway shows played Baltimore, New Haven, and Philadelphia before opening in New York. Miss America showed up to cut the ribbon at the new Woolworth's in every little town, and major motion pictures rolled out slowly across the country, moving from big cities like New York and L.A. through secondary markets until they finally reached towns like Peoria, Illinois, or Lancaster, Pennsylvania. Back then, it was much easier to come into contact with what we now call celebrities. Of course, back then they were simply known as "stars."

Even in small towns, films needed to be sold, and one of the mainstays of publicity campaigns was to have one of the film's cast members sign autographs and pose for pictures at a local premiere. When Peggy Wood, who played Mother Abbis in *The Sound of Music*, came to Lancaster on such a mission, it was a defining moment in Gary Boas's life. Boas dreamed of being a movie star even though he could not stand in front of his class and give a book report, an event which led to his being home-schooled at thirteen. Peggy Wood was the closest he'd ever been to Hollywood, and—as he would many times in the years to come—he sat down to write a letter. He confessed his ambitions to Mother Abbis; she responded with a two-page letter encouraging him to think of another career. It was advice he didn't take (it took famed acting teacher Uta Hagen to accomplish that when in 1971 she told Boas after just one class that another line of work might be in order), but Peggy Wood taught Boas one thing: despite their fame, stars were human enough to appreciate and respond to someone who admired them.

After exchanging notes with Wood, Boas began to write hundreds of letters to actors he saw in movies, plays, and on TV, usually asking for an autographed photo. He sent care packages to the stars of his favorite television shows. Summer-stock productions inspired letters to every member of the cast. He wrote to the seven original Mercury astronauts, keeping up with the space program through the Apollo moon shots. Even politicians attracted his interest: he contacted not only all the living presidents, but also their wives, their children—even their pets. And he was nonpartisan, sending out letters to both J. Edgar Hoover and Fidel Castro (apparently, the latter didn't send out 8x10s). He even ventured overseas, sending affectionate notes to the Queen of England and the Pope. He estimates that his letters had more than a 90 percent response rate; by the mid-seventies, the responses numbered in the thousands. The letters and notes that the famous enclosed with their photos were by turns heartwarming, querulous, or avuncular, but they were nearly always personal—less the product of a press agent's campaign than a nod from a distant but friendly acquaintance.

When singer Robert Goulet showed up in Lancaster in 1966 for a United Way fund-raiser, fifteen-year-old Boas ran home and returned with his Brownie Bullseye. It was the first celebrity photo he made himself, and it extended his hobby into a new dimension. In the weeks to come he found opportunities to make photographs of Miss Universe 1966, Richard Chamberlain, and Mary Tyler Moore. The boy whose shyness had once been so crippling that he had

Gary Boas
in his bedroom
Lancaster, PA
ca. 1966

Richard Chamberlain
in *Holly Golightly*
Forrest Theatre, Philadelphia, PA
Saturday, October 29th, 1966

Mary Tyler Moore
in *Holly Golightly*
Forrest Theatre, Philadelphia, PA
Saturday, October 29th, 1966

to be home-schooled discovered that his photos bridged an emotional gulf he had been unable to cross on his own. Casting him in the role of documentarian, the camera gave him the reason he'd needed to approach stars in person.

The photographic project gained momentum, and Boas discovered that his pictures could capture the attention of those who might once have brushed him off. Boas found this attention as rewarding as meeting the stars, but like the people he photographed, he understood that he was only as good as his last picture. His friends would look at the same photo and listen to the same story only a few times, so he had to keep coming back with new shots. Although the Valley Forge Music Fair was nearby, the real action was in Philadelphia, where the *Mike Douglas Show* was taped. Ferried there by a pal with a driver's license, Boas began taking his camera to Philly whenever he could get away from home.

Daytime talk shows in the sixties were a different breed from the Jerry Springers and Ricki Lakes—even the Oprahs—of today. Mike Douglas, an affable if somewhat lightweight Irish tenor, didn't want to know about his guests' darker sides. No one cried, no one unburdened themselves of their sins; they simply came on and chatted and performed. And when they walked off the stage after the show, they were more than happy to stop for a moment, sign autographs, and pose for snapshots.

This seemed like heaven to Boas, but it was not enough. Since he already had an interest in theater (having worked with a local drama group), New York was the logical next stop. There, he soon discovered an underground network of collectors who were just as obsessed with stars as he was. Boas describes them as a motley crew: mainly older, quirky misfits who were socially awkward yet incredibly efficient when it came to chasing after a star to get an autograph.

Even in this group Boas cut an eccentric figure, roaming around Broadway with his camera hung around his neck, hauling two worn duffel bags and a backpack stuffed with more than a hundred pounds of movie-star books, newspaper clippings, *Playbills*, and magazine articles. As they stood outside hotels or stage doors—often for seven hours or more—Boas and his new friends swapped stories and gave each other tips about which stars were in town and

where they were staying. The easy camaraderie gave him a sense of belonging, and his new friends would even put him up on his increasingly frequent visits to town.

Back in Lancaster, Boas became something of a star himself, his collection winning "Best of Show" at two local hobby fairs. But the only way he could support his growing habit and still have enough time to pursue it was to take jobs on the fringe of society: menial, minimum-wage, unsavory. He first worked as a stock boy at a Turkey Hill grocery store, then as a department-store window dresser, and soon after as a factory worker (a career that ended after he tripped on a power cord, breaking two teeth, which embarrassed him to the point that he couldn't return). Ultimately he ended up behind the counter at The Old Book Store, Lancaster's only adult bookstore/headshop/peepshow, where he remained for the next ten years. It was there, he says, that he was thrown into what he called the "odd" world, and, he adds, "I was odd to begin with." But his oddness did not keep him from mingling with what he calls the "hoity-toity" segment of Lancaster society through his volunteer work with the community theater group, where he directed and choreographed seven productions.

By the mid-seventies Boas' autographs, letters, and photographs had become a formidable collection. Albums of memorabilia filled his bedroom, taking up more space just as his hobby began to take up more time. According to an intimate friend, the hours spent taking photographs, writing letters, and maintaining his collection became a second full-time job.

The photographs are a varied bunch. Anyone who caught his eye—from an above-the-title star to the chorus boy in the back row—was suitable for a photo. Boas' collection, which today spans more than sixty thousand photos, is nothing if not democratic. The fact that he would only shoot one or two frames per sighting, often waiting hours to photograph one person, makes the sheer number of images in his collection that much more extraordinary.

As a result of his all-inclusive methods, Boas uniquely captured a number of stars well *before* they became stars. His photos of Glenn Close and Kevin Klein when they were still known only to theater audiences, years before they appeared on film, are among the first fan photographs ever made of these now-renowned film actors. At the same time, Boas photographed stars near the end of their long trajectories, well after their fame had faded from the general public's consciousness. His images of one-time matinee idol Robert Montgomery as an octogenarian, or Janet Gaynor, the first Academy Award-winning actress, some twenty years after her last film, are just as fascinating as the early "discoveries" he made. His recognition of these stars was almost invariably well received—the warmth they felt toward him for his continued attention is obvious in the images themselves.

Boas approach as a fan and documentarian is a remarkably wide-ranging view, anticipating the vertically integrated, cross-promoted, synergized media culture where a singer can turn actor then best-selling author, then morph into a corporate pitchman or politician. Today, celebrities are no longer treated merely as entertainers but also as profit centers and commodities, protected and doled out in controlled portions. As the stars themselves have receded from public view, their images have become more prevalent. A single photo can appear in newspapers and magazines, on network and local newscasts, and repeated endlessly on twenty-four-hour cable networks and the Internet. In the waning days of the twentieth century, celebrity is omnipresent. It's a state of affairs that has made it almost impossible for Boas and his friends to continue their activities as fans.

Most celebrity photos today are edited even before the shutter is released. Some celebrities will not consent to be shot unless they are promised that they will appear on a cover, and prior approval of the photographer, the stylist, and the editor is *de rigeur*. Photos taken without consent are no less controlled. The paparazzi photos that appear in the tabloids and alongside gossip columns are sifted with an agenda about the star in question,

and lurking in the background is always the knowledge that even the most modest and seemingly offhand of these photos was taken with one eye on a paycheck.

Given the current situation, it's no wonder that many of the fans Boas met along the way eventually turned their hobbies into their professions. Like Boas, they already have the celebrity radar. ("I have a sixth sense for spotting them," Boas explains. "I can look at a crowd of a hundred people, and can instantly tell who is famous." He doesn't even need to have an idea who they are. He says, "I just know.") But the transition from fan to professional is never easy. Among paparazzi, being called a fan is a putdown: a fan is a non-pro who gets in the way. A shot with a fan in the frame is practically worthless; a fan behind the lens is worth even less. And in the hard-bitten, tabloid atmosphere of the paparazzi, asking for an autograph is strictly *verboten*.

Boas turned professional about ten years ago. Though he can hunt down the celebrities, he's not especially successful as a paparazzo; the rush to shoot several rolls of film, log, develop, and get the shots out is antithetical to a man more comfortable in the hermetically luxuriant world of the collector.

Then too, Boas has seen many of his former-fan friends develop brittle exteriors as paparazzi. Turning professional forces them to bottle up their enthusiasms. For most of them, just getting a photo doesn't satisfy; they need more contact. But seeking such contact nowadays can be precarious. Two years ago Boas was arrested for criminal trespassing at the Hershey Hotel in Hershey, Pennsylvania, while waiting to photograph the US Olympic Gymnastics Team. After Mark David Chapman shot and killed John Lennon in 1980, stage-door guards began to treat fans with real suspicion, viewing the most ardent fans as potential stalkers. It's a state of affairs that is causing Gary Boas to consider laying down his camera. If that were to happen it would be a sad day, not because the world needs another paparazzo, but because in the manufactured celebrity generated by today's publicity machine there is no longer a place for a person with the heart of an amateur fan.

Meanwhile, Boas has turned a hobby into an art form. Through his singular vision he has created a vast, complex statement about a period in our culture that is passing from view. His work reveals that culture from a perspective that, until now, has never been deemed worthy of publication.

In keeping with the fiscal imperatives of our consumer culture, collections of celebrity memorabilia, like "high art," no longer are appreciated; now they are appraised. The worth of autographs and photos fluctuates like a human stock market (to the point where there is an online rotisserie league of fame, with celebrities bought and traded, their price often based on their latest movie grosses).

Boas's photos exist outside that world. They lack any economic subtext; as difficult as it might be to believe, the Boas photos published here were taken not for money, but from a passion and consideration for his subjects. This approach characterized his methods thirty years ago and still separates him from the new crowd of "professional fans." When Broadway legend Chita Rivera—who Gary befriended nearly two decades ago—was asked what set Gary apart from the other fans, she responded with a fan letter of her own. From the first time she saw him, "Gary's face and smile stood out in the crowd of hysterical, rude, overenergized photographers. I heard my name spoken with warmth, and it was Gary. He is also the only one who had his own picture taken with you, so you felt a warm, sweet person lived behind the camera."

In the pictures here, you can still catch the flash of excitement of a young man from the sticks when he sees in the flesh someone he knew before only from the dream world of fame. Gary Boas never cared about deals or points—he cared only that he was in the presence of a star, and he wanted to commemorate that moment. His photographs are, in the end, a kind of love. Savor them. In today's world such photographs are rare, and fans like Gary Boas, rarer still.

Boas's Booth
at the Optimist's Hobby Show
Lancaster, PA
1975

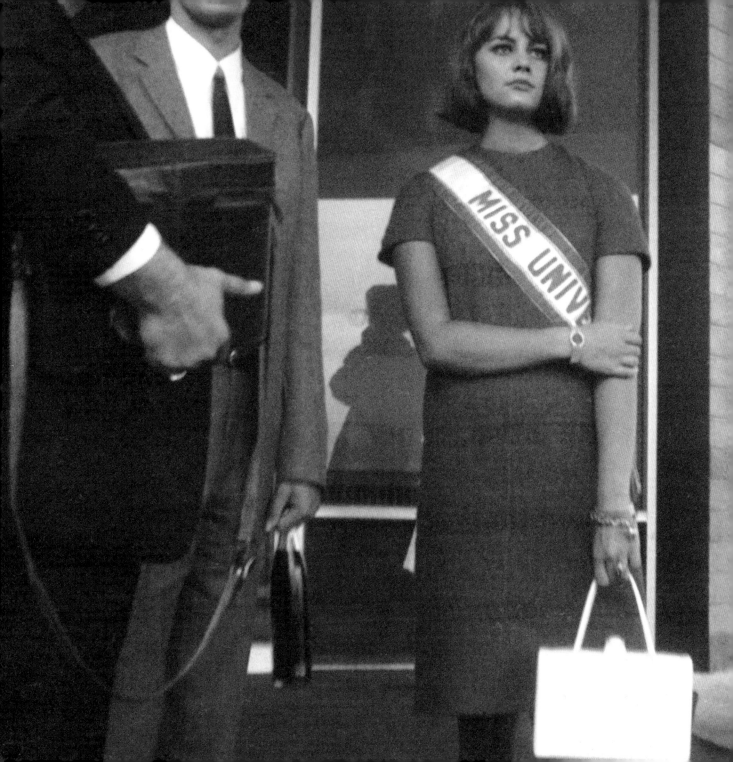

the early years

Betty Grable
in *Guys and Dolls*
Valley Forge Music Fair, Devon, PA
Saturday, June 15th, 1968

The tent at Valley Forge is what introduced me to summer stock theater. Back in the sixties and seventies on the East Coast in the summers they would have these theater tents that featured traveling plays and musicals. There was a circuit of about four tents throughout the east coast, and Valley Forge was about thirty miles from my house. The tent would be there all summer long, and in the winter they would just take it down and it would be a vacant arena until summer came again. It was like theater in the round in a circus tent, and you would sit in director's beach chairs—it wasn't like seats in a row—and they had maybe eight aisles that would come down, and the actors would just stand up in the back until it was their time to go on the stage. There was really no set, just a lot of props to imply a set because they had to play from all angles, all the way around.

They always had an established star playing in the lead, although that person was never the top film or Broadway star of the moment. All kinds of stars would do it—anywhere from a fading screen legend to a hit TV-series star on hiatus—but there was always one famous actor who was the draw. I saw Jayne Mansfield there in *Gentlemen Prefer Blondes*, Martha Rae, Richard Chamberlain, Anne Southern. If an actor signed to do a play for the summer, they would play two weeks here, two weeks there... they'd work maybe eight to ten weeks, touring the tent circuit in whatever play it was they were doing.

A lot of this was very demanding on them. The dressing rooms for the stars looked like horse stalls. They were just like thrown-up shacks. Today's stars would never do it. But back then it wasn't like you were stepping down, it was just part of what you did. It wasn't like "Oh my God, I'm playing the Catskills!" It wasn't that attitude. You just kept working. In fact, most stars that are still around I'll say, "I saw you do this at the Valley Forge Music Fair," and they just stop dead in their tracks, no matter what they're doing or signing. It seems to take them back to another world—one that they greatly valued.

Because I was younger and didn't know the caliber of stardom of these people, when I met Betty Grable, I had no idea she was the pinup girl of World War II: I was meeting Betty Grable, who was doing the lead in *Guys and Dolls*. I don't know how old she was—I think in her fifties.

The Golddiggers 1971
in front of the Host Farm Resort Hotel
Lancaster, PA
Friday, August 13th, 1971

Jacqueline Britt and Harriet Conrad
in *Gypsy* at the Hershey Theatre
Intercourse, PA
Friday, August 21st, 1970

Gordon MacRae
in *Golden Rainbow*
Valley Forge Music Fair, Devon, PA
Wednesday, July 9th, 1969

James Caan
filming *Rabbit, Run*
Reading, PA
Thursday, July 24th, 1969

Joanna Lester
in *Gypsy*
Valley Forge Music Fair, Devon, PA
Saturday, August 5th, 1967

Deborah Bryant: *Miss America 1966*
at Franklin and Marshall College
Lancaster, PA
Saturday, November 2nd, 1968

Ursula Andress
inside Saks Fifth Avenue
New York City
n.d.

Mamie Van Doren
in *How to Succeed in Business
Without Really Trying*
Hershey, PA
Monday, June 29th, 1970

Sean Connery
filming *The Molly Maguires*
Eckley, PA
Thursday, July 18th, 1968

Anthony Perkins with Mary Boas
in *Star-Spangled Girl*
Forrest Theatre, Philadelphia, PA
Saturday, November 26th, 1966

Connie Stevens with Mary Boas
in *Star-Spangled Girl*
Forrest Theatre, Philadelphia, PA
Saturday, November 26th, 1966

Ginger Rogers
in *Hello Dolly*
Forrest Theatre, Philadelphia, PA
Sunday, April 28th, 1968

I always wanted to be a dancer. I had to leave school in seventh grade because I would literally get ill if I had to get in front of a class. As soon as the teacher shut the door, I had claustrophobia from hell. I felt imprisoned. I didn't feel like the rest of the kids: I was awkward, I had red red hair, I was skinny, I had freckles... but when I was dancing, I didn't feel awkward anymore. I was graceful. I knew I was a good dancer, and I felt confident about it, and when I was dancing I was in a group so I didn't feel the focus was on me.

I didn't actually get to dance on stage until my senior year when they were doing *Li'l Abner*. I finagled getting on the stage crew (I couldn't technically be in the play because I was what they called "homebound"). But they needed a dancing outhouse for the Sadie Hawkins scene in the play and somehow, because I was able to be incognito, I ended up as the dancing outhouse. After that, I was in the stage crew for other theater groups, and people kept putting me in shows as a dancer because I was thin and agile.

Every time I would approach a famous dancer for an autograph, I would ask him or her to perform some dance steps for me... it was my thing, so that in my own little way I could always say I danced with that person. Fred Astaire was the first person I tried, and he very graciously accepted. He was very approachable... he was always very pleasant and graceful—such a Dapper Dan, always with the old-style star tux and tails.

Over the years I ended up dancing with Gene Kelly, Donald O'Connor, Ann Miller, Cyd Charisse, Eleanor Powell, Ruby Keeler, Bob Fosse, Marge and Gower Champion—most all of the MGM musical stars, and many more. Usually they would just do a few steps, but Ginger Rogers actually took me and *danced*. It was a little awkward because she was leading, and I wasn't exactly sure which song she was dancing to. Nobody has ever turned me down until recently, and that was Tommy Tune, of all people!

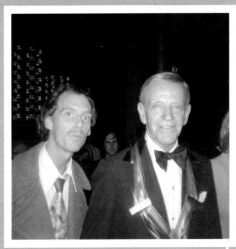

Gary Boas with Fred Astaire
at the Kennedy Center
Washington, D.C.
December 1978

Joan Bennett
shooting *Dark Shadows*
ABC Studios, New York City
Wednesday, June 4th, 1969

Jonathan Frid
shooting *Dark Shadows*
ABC Studios, New York City
Wednesday, June 4th, 1969

Richard Harris
outside the Ed Sullivan Theatre
New York City
Sunday, April 28th, 1968

Patricia Neal
outside the *Tony Awards*
Mark Hellinger Theatre, New York City
Sunday, April 19th, 1970

Jim Nabors
at the York County Fair
York, PA
Thursday, September 14th, 1970

Johnny Unitas
at the York County Fair
York, PA
Thursday, September 14th, 1970

Rock Hudson
at the *Dick Cavett Show*
New York City
Wednesday, March 31st, 1971

Burt Bacharach
in *The Marlene Dietrich Review*
New York City
Saturday, October 28th, 1967

Gladys Knight
at the *Joey Bishop Telethon*
the Academy of Music, Philadelphia, PA
Sunday, September 8th, 1968

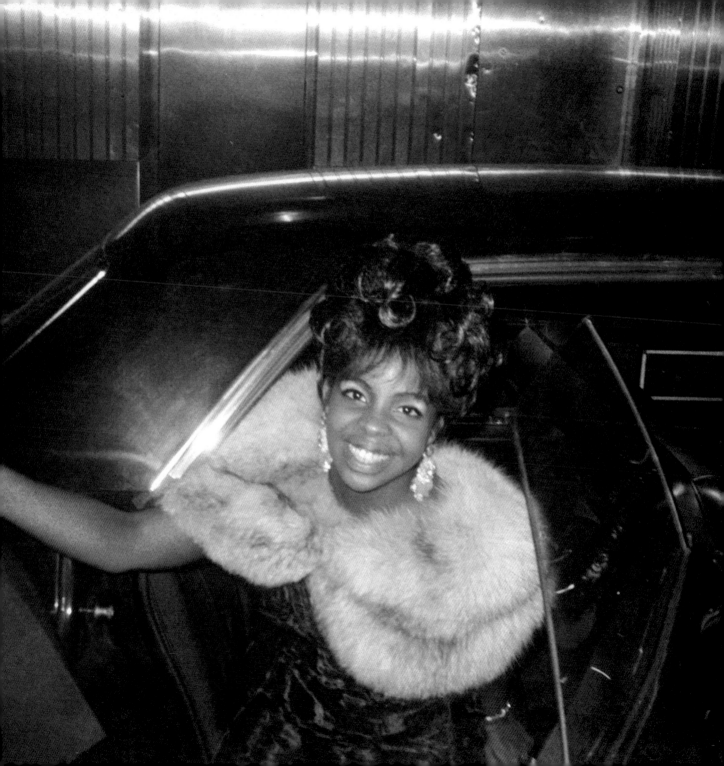

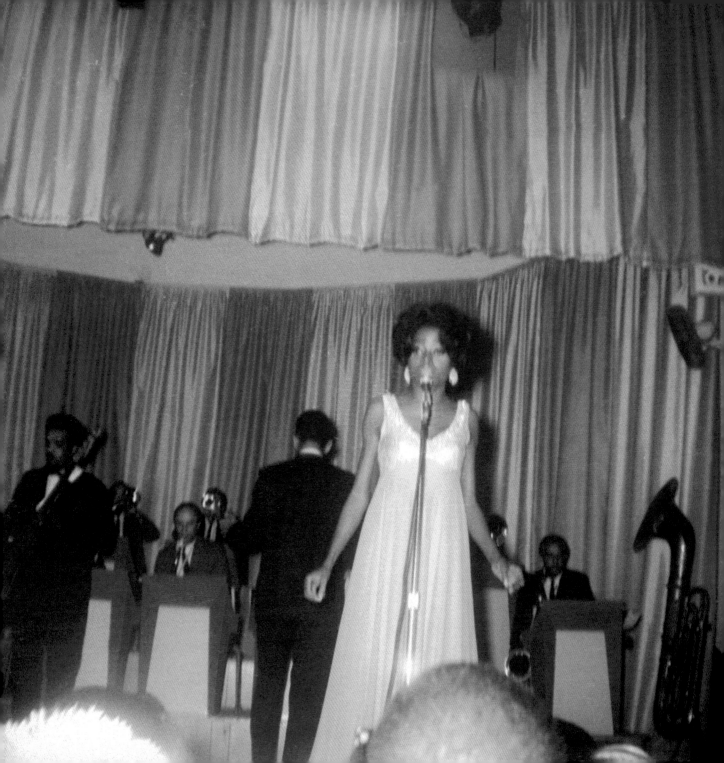

Diana Ross
with the Supremes
the Steel Pier, Atlantic City, NJ
Saturday, August 19th, 1967

The Steel Pier was a big thing in its day. You paid one price to get on the Pier and you'd get two movies, a live show, and a whole pier with amusements on it. I saw Paul Revere and the Raiders there, the Young Rascals, the Supremes, the Beach Boys—it was a famous place. They actually used to have this diving horse that would stand on the edge of a diving board, with a blind girl sitting bareback on it and somebody behind it pumping it to go. It'd jump way up in the air and into a pool. The horse did this three times a day.

Two movies, the seashore, a diving horse, and some of the biggest acts of the day... all that for $4.50— you couldn't beat it. Then again, this was when it was still a family-oriented place, no gambling, it wasn't like it is today... there wasn't any of that. Everything was so much simpler and easier. It caught fire in the late seventies, then they tore it all down and built the casinos. It had been there for decades.

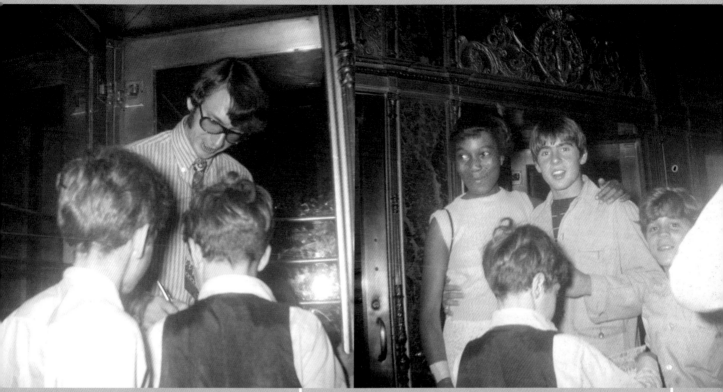

Michael Nesmith
at the Warwick Hotel
New York City
Wednesday, July 25th, 1967

Davy Jones
at the Warwick Hotel
New York City
Wednesday, July 25th, 1967

Jeremy Clyde
in *Black Comedy*
the Forrest Theatre, Philadelphia, PA
Saturday, May 11th, 1968

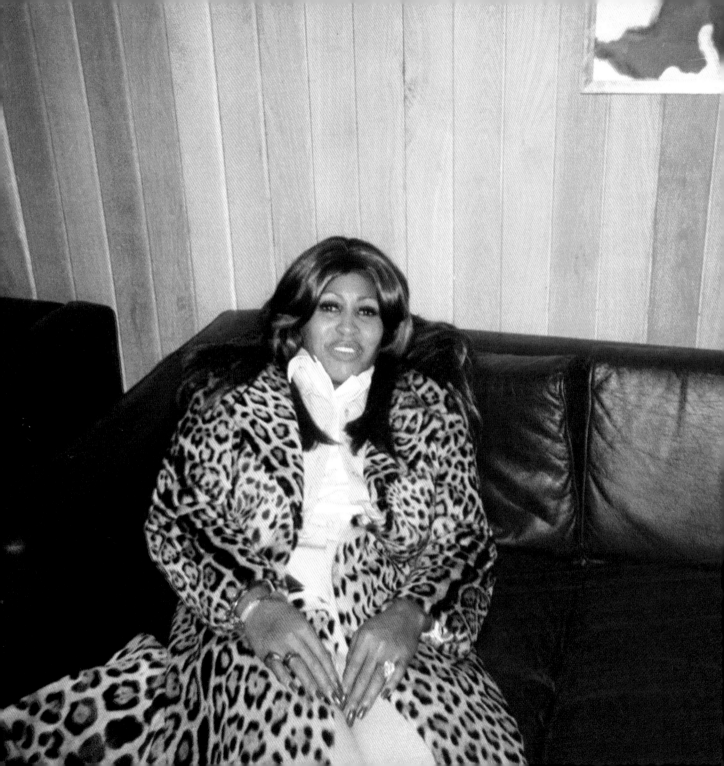

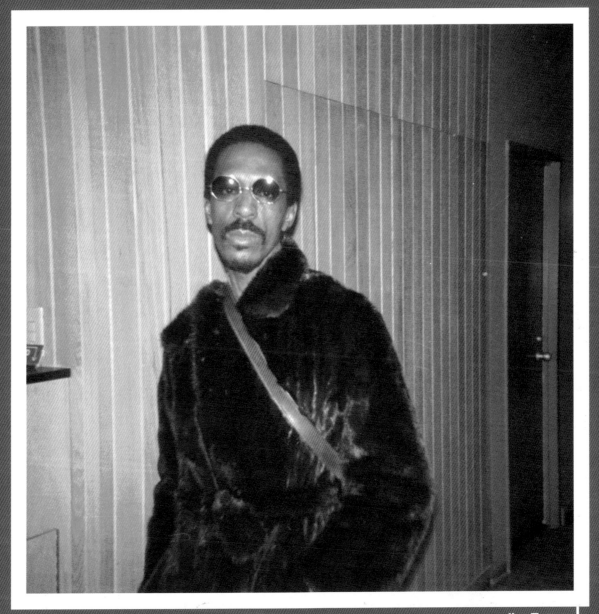

Ike Turner
at the Brunswick Hotel
Lancaster, PA
Friday, March 10th, 1972

Tina Turner
at the Brunswick Hotel
Lancaster, PA
Friday, March 10th, 1972

Dale Evans
in front of WGAL-TV
Lancaster, PA
Tuesday, September 14th, 1971

Roy Rogers
in front of WGAL-TV
Lancaster, PA
Tuesday, September 14th, 1971

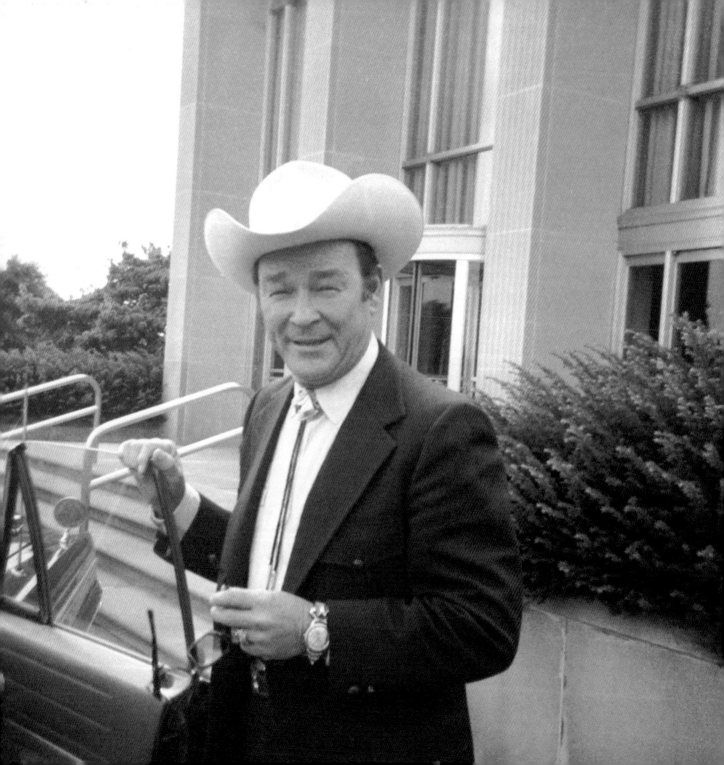

Pat Boone
at the *Mike Douglas Show*
Philadelphia, PA
Thursday, September 3rd, 1970

Mahalia Jackson
at the *Mike Douglas Show*
Philadelphia, PA
Thursday, September 25th, 1969

Kenny Rogers
in front of the Plaza Hotel
New York City
Thursday, May 18th, 1972

talk shows and telethons

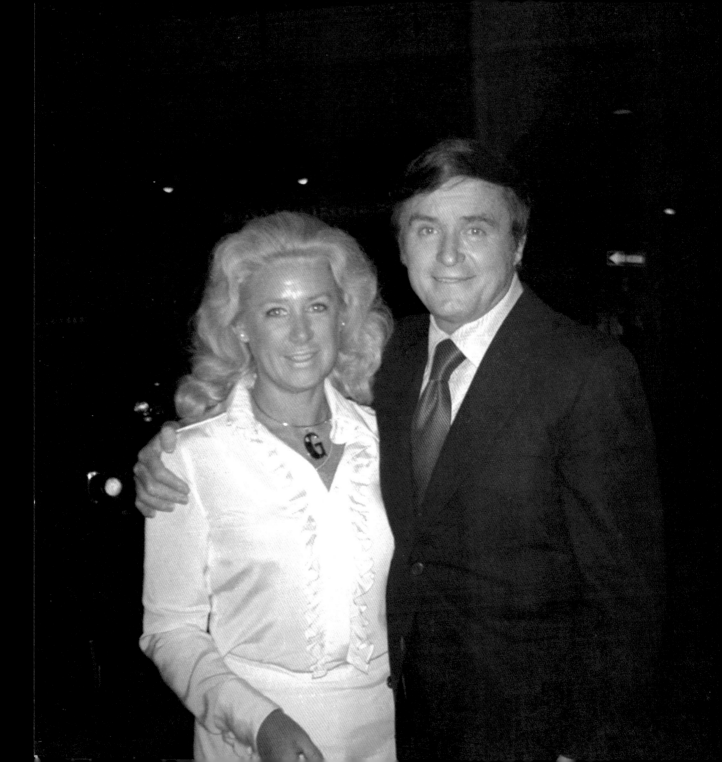

Mike Douglas with his wife
outside the *Bob Hope Flood Relief Telethon*
the Hilton Hotel, Baltimore, MD
Saturday, July 22nd, 1972

The *Mike Douglas Show* in Philadelphia was when I started really scoring big. He didn't have a co-host like Johnny Carson had Ed McMahon. Instead he would have guest co-hosts—sometimes, really major stars—anyone from, like, Bette Davis to Florence Henderson. The guest would be there every day to co-host the show, and he had a different one every week. And other stars would come on the show that week because they were connected to the guest co-host.

I was just old enough that I could drive down to Philadelphia if I could find a licensed driver to go along, because I only had a learner's permit. Since I was being home-tutored and wasn't in school, you could say I sort of sneaked out, although there was really no one to sneak out from. My guardian Marian didn't care, and a lot of the time she would come out with me. She didn't have anything better to do. Philadelphia was about an hour and fifteen minutes away, and Mike Douglas would always film early in the afternoon. I'd get down there by noon and be home by suppertime.

This was the first opportunity I had to figure out the system of how to approach stars at talk shows. They filmed the show every day of the week, and the people who were in the audience usually had no clue about how to find the stars outside of the show, so there was very little competition to have encounters and get things signed. They had a front door and a back door, and the bigger celebrities would go out the back door, so you had to keep an eye out for the limousines. They usually stayed at the Warwick Hotel a block away, so oftentimes they just walked from the hotel. Celebrities didn't go out of their way to be evasive back then. Fans weren't something they would try to avoid. The bigger stars like Bette Davis definitely went out the back, but she was still approachable—it wasn't like she was getting away.

Later on I would wait outside several different talk shows in New York. Most of the time I was running around town, and I very rarely went into the shows as an audience member. I would just hop around and hit the *Tonight Show*, then the *Dick Cavett Show*, *David Frost*, *Merv Griffin*, and so on. It was a sure way to get a steady stream of stars on a daily basis as they were coming or going. Anybody who was there waiting like I was was usually there because they were especially obsessed with one celebrity who was appearing that day. Me and a few other people were the rarities, because it didn't matter who was there—we wanted to get everybody.

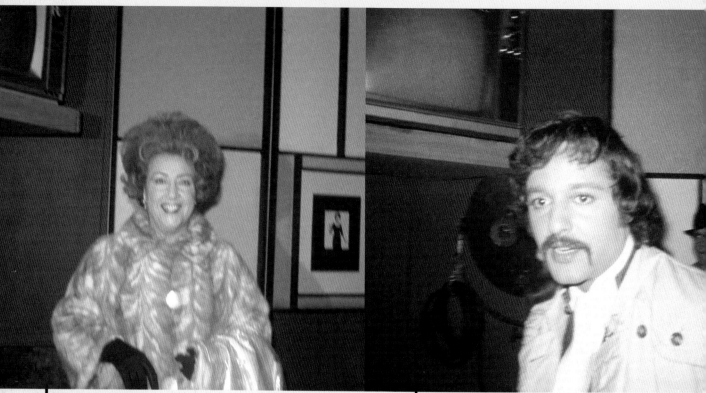

Ethel Merman
at the *Mike Douglas Show*
Philadelphia, PA
n.d.

Sal Mineo
at the *Mike Douglas Show*
Philadelphia, PA
Thursday, February 26th, 1970

Lucille Ball
at the *Mike Douglas Show*
Philadelphia, PA
Thursday, January 22nd, 1970

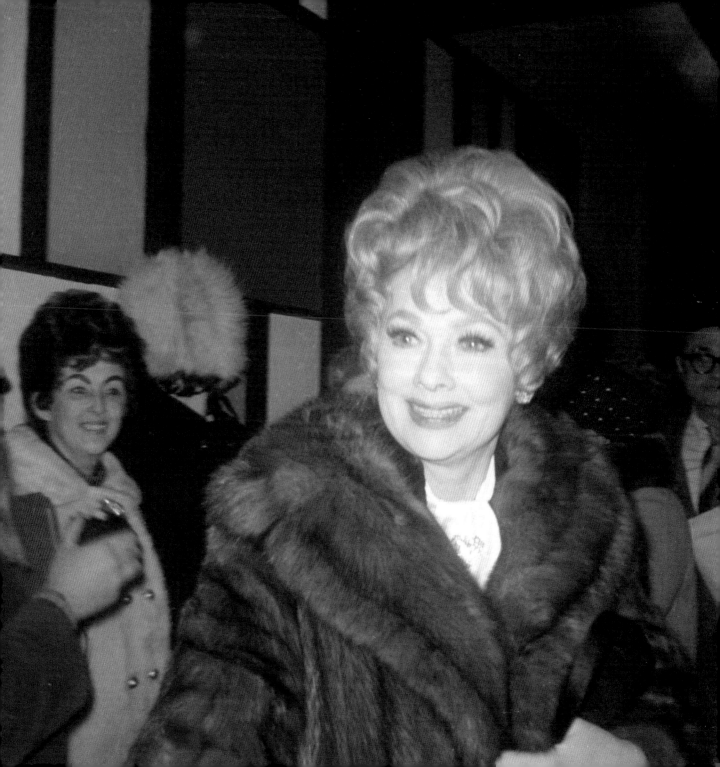

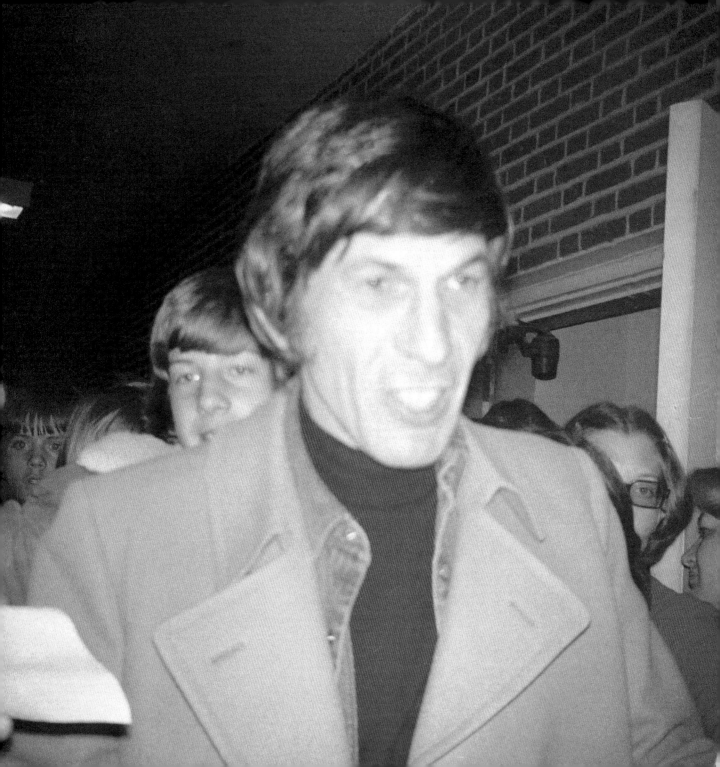

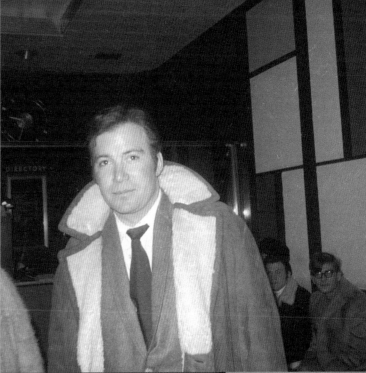

William Shatner
at the *Mike Douglas Show*
Philadelphia, PA
Thursday, January 16th, 1969

DeForest Kelley
at the *Mike Douglas Show*
Philadelphia, PA
Thursday, January 16th, 1969

Leonard Nimoy
Millersville State College
Millersville, PA
Monday, December 8th, 1975

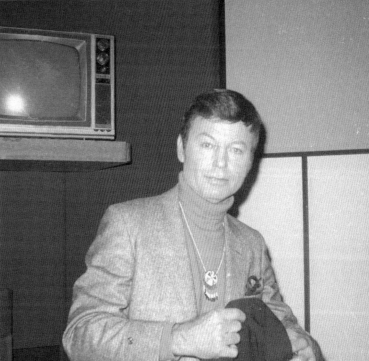

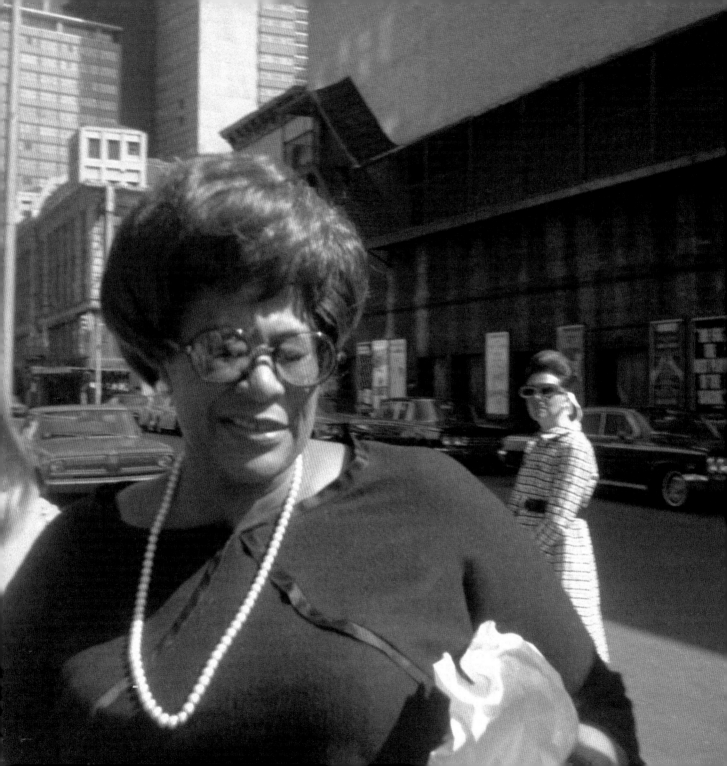

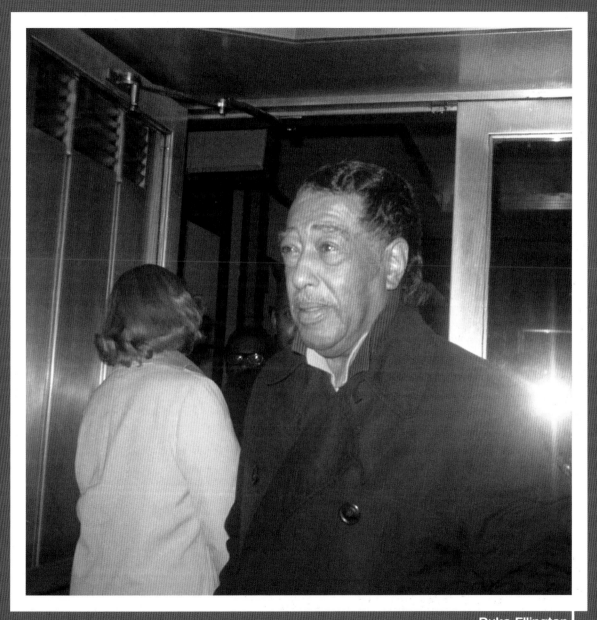

Ella Fitzgerald
at the Ed Sullivan Theatre stage door
New York City
Sunday, April 27th, 1968

Duke Ellington
at the *Mike Douglas Show*
Philadelphia, PA
Thursday, December 5th, 1968

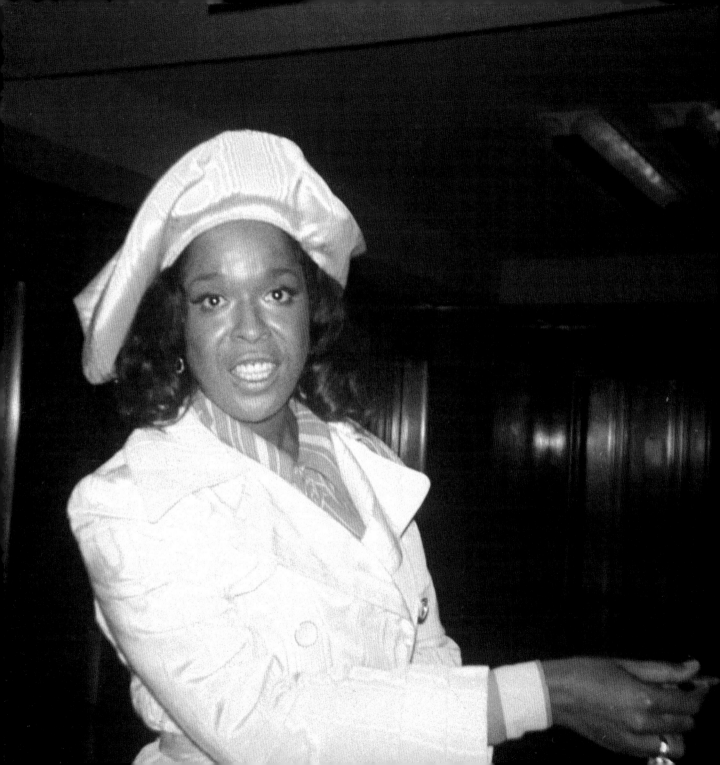

Liberace
at the *Mike Douglas Show*
Philadelphia, PA
Wednesday, October 29th, 1970

Rip Taylor
at the *Mike Douglas Show*
Philadelphia, PA
n.d.

Della Reese
at the *Tonight Show*
New York City
Thursday, September 23rd, 1971

Bob Newhart
at the *Ed Sullivan Show*
New York City
Sunday, February 1st, 1970

Soupy Sales
at the *Mike Douglas Show*
Philadelphia, PA
Thursday, September 25th, 1969

Sebastian Cabot
at the *Mike Douglas Show*
Philadelphia, PA
Wednesday, April 9th, 1969

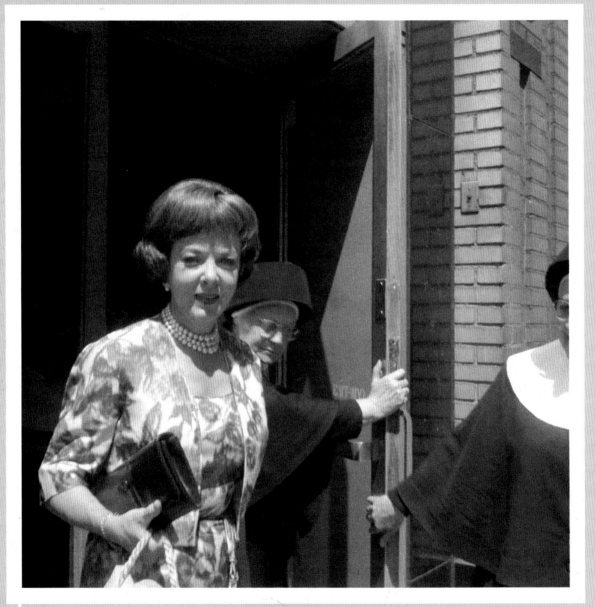

Ida Lupino
at the *Mike Douglas Show*
Philadelphia, PA
Sunday, June 7th, 1978

Charles Bronson
at the *Mike Douglas Show*
Philadelphia, PA
Thursday, September 9th, 1976

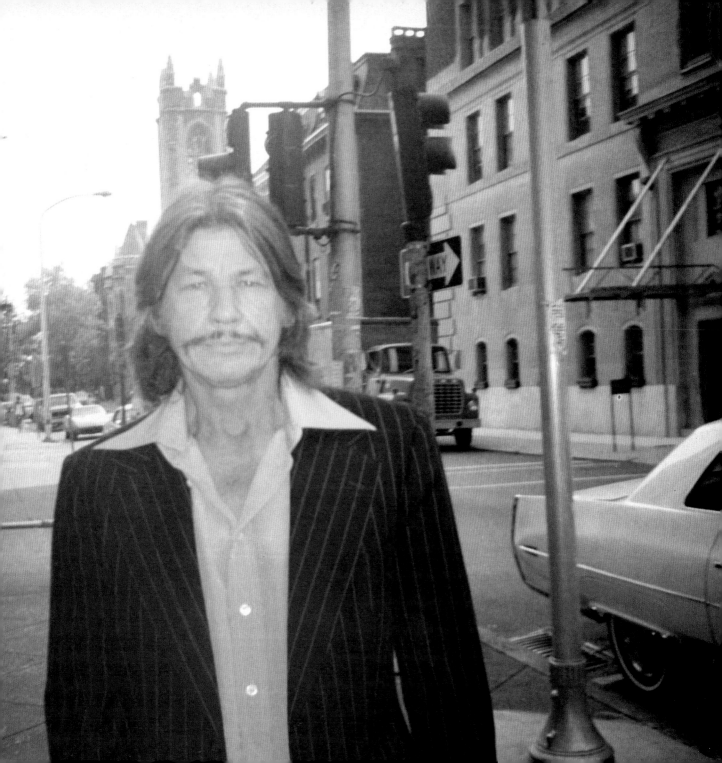

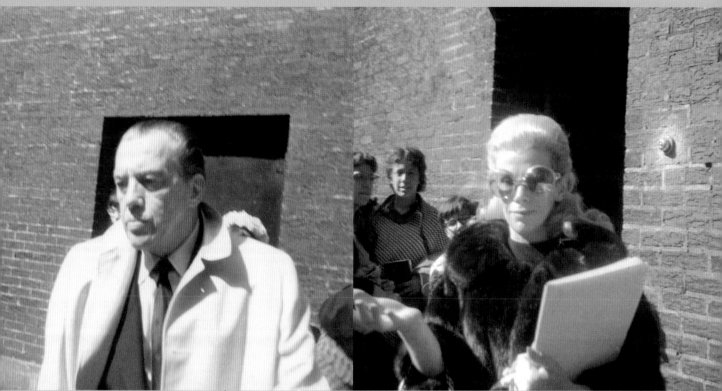

Ed Sullivan
outside the Ed Sullivan Theatre
New York City
Sunday, April 28th, 1968

Joan Rivers
outside the Ed Sullivan Theatre
New York City
Sunday, April 26th, 1970

Truman Capote
on *What's My Line?*
Ed Sullivan Theatre, New York City
Thursday, September 22nd, 1968

David Frost
outside the *David Frost Show*
New York City
Thursday, September 22nd, 1970

Merv Griffin
outside the *Merv Griffin Show*
New York City
Wednesday, June 4th, 1969

Ed McMahon
at the *Tonight Show*
NBC Building, New York City
Thursday, September 24th, 1970

Doc Severinsen
at the *Tonight Show*
NBC Building, New York City
Friday, November 17th, 1972

Johnny Carson
at the *Tonight Show*
NBC Building, New York City
Thursday, April 1st, 1971

Jerry Lewis
at the *Tonight Show*
New York City
Thursday, September 24th, 1970

Joey Bishop
at the *Joey Bishop Telethon*
Academy of Music, Philadelphia, PA
Sunday, September 8th, 1968

Unidentified collector, Celia, and "Pops"
in front of the Kyoto Steak House
New York City
n.d.

Fans who are collectors are the most bizarre-looking and -acting people, and I don't mean this disrespectfully, because I'm one of them. But somehow, they all look a tad bit off. Back in the day, some of them would be dressed all glamorous, and some of the others had four teeth in their mouth. If I was a star and I saw them while I was coming out of a building, I might run. It was like a Fellini movie. But they were all the biggest sweethearts. We were a family. Even now I get a lump in my throat when I think about them. I have so many great memories about these people and I miss them, especially when I think about what it's like today versus what it was then—there's no comparison.

Each city had its own special brand of fans. There was a whole crew that hung out in New York for a while getting autographs—older people, mostly—who if you didn't know them... well, they were practically street people. I'd say there were about twenty of us. We all hung out together, but we didn't know each other beyond when we were hanging and waiting for people. We never talked about our personal lives; that wasn't part of what we chit-chatted about because we were so busy comparing notes.

We would meet in the Manhattan and Edison Hotel lobbies (those were our toilet stops; it was difficult to find a public toilet off the street) and then at Ray's Pizza on 8th Avenue to swap stories and network for the day. There was always that great feeling when you saw someone on the street, because you had that common bond. You actually went out in the day looking forward to seeing your friends. We'd wait together all the time for people—first it would be fifteen minutes, then it would turn into a half an hour, and then, sometimes, half a day. If we were together, it was easy to wait for hours. We stood around and just chatted and chatted. It was always a very warm and supportive atmosphere. The sad part is, when I go to New York nowadays, either those people have passed or they've given up schlepping things around.

Celia was the most infamous, she and Good Humor Man David. He was a Good Humor ice cream man by day. He had about three teeth, and all these hairs growing out of his nose and ears. He'd go around and ask everybody, "Are you anybody? Are you in show business?" If you were pretty or had a fur coat on he'd say, "Are you somebody?," then he'd ask if you had a quarter. And sometimes stars would give him fifty bucks or a hundred bucks. So he was in the in crowd. He just got autographs on a tablet; I don't know how he kept his stuff in order.

Celia with Hal Linden
at the *Tony Awards* party
Americana Hotel, New York City
Sunday March 28th, 1971

Celia knew everybody. She had this voice that sounded like she was sliding a whistle down her throat when she talked—all these weird noises—and if you'd ever tell her somebody had died who she liked she'd go, "Aaaoooooh," and she'd look up at heaven and talk to them, and she'd get a tear in her eye. She used to run around with this woman named Pearl who had bug eyes and fire-engine-red lipstick and a little leopard hat. When Pearl died Celia kept saying, "She got one of them ice cream rushes and died. I'll tell you, she ate it too fast. It killed her—you know, it freezes your brain up. I told her she ought to stop on that stuff."

Celia was in love with Ian McKellen. She would wait at his stage door every night when he was doing a play, and all the other fans would tease her about him being gay. She was so heartbroken when she finally found out it was true. Richard Burton used to take Celia and bend her over and kiss her in front of everyone. Here he was married to Elizabeth Taylor, and he's kissing Celia, just to get her going. Everybody knew her: Merv Griffin—Celia was his favorite. He'd pick her up and hug her and laugh with her and sometimes bring her in and sit her in the audience during his show. In 1998 I had to tell him that she had died. It was at an event in L.A. He was standing alone, waiting for his car, and I went up—and here's Merv, a multimillion-dollar man—and I walked up and just started chatting with him. I said, "I just had to tell you this—did you know Celia Gordon?" He said, "Oh my God, yes, I know Celia. How do you know Celia?"

I said, "Well, we used to hang out at the Little Theater when you did your show in New York."

He said, "Oh my God, I haven't seen her in years, I just don't get back to New York." And I told him, "Well, she just died in April." He got all choked up. He got red in the eyes, and you could see that it really moved him.

There are certain telltale signs of an autograph collector: we've got ink stains everywhere, usually on our pants and our hands. I always have an ink stain on me—my pen leaks in my pants pocket all the time— and I practically have a permanent big blue ink spot on my leg. Also, everybody has their own little format of what they collect—autographs on index cards, newspaper clippings, 8x10's, books, match packs—and everyone has their own method to their madness in how they keep things organized and what they get signed, and why and how important it is to have that signed. Some people have to have fifty record albums signed, somebody else has to have every single cast member sign a *Playbill*, another person has to have every single letter in someone's name.

This one woman, Marlene, she collected mainly out of Baltimore and D.C. I don't know how she knew what the hell she was doing, because if you looked at her she was one of the most disorganized people, but she'd have, like, twenty books, like I used to, with all kinds of bookmarkers hanging out with the initials of whoever she needed written on them. She looked like a Bible freak. And she's still around: she's been that obsessive for

Pearl with Johnny Carson
outside the *David Frost Show*
New York City
Thursday, September 22nd, 1970

years; I think she's in her fifties now. She's still throwing these books around, and they're all beat up to hell and half the pages are ripped, and you'd think, why is she getting these books signed, they're falling apart—but it's very important to her. If I were carrying my books around, that's what they'd probably look like, too. She's just been carrying them around forever.

There was one old man with thirteen children who collected. His real name was John, but we used to call him "Pops." He would shuffle down the street with a shopping bag and a he had cigarette hanging out of his mouth like his lower lip was an ashtray. He had no teeth—not a single one. He was so bowlegged, you literally could crawl through his legs. And poor—I mean poor till it looked like his shoes were falling off his feet and everything. At the time, I would walk all over New York: I was young, I was brave. Take a cab or a subway? You've got to be kidding—there's things to see. Oftentimes he'd hang out with me and the other collectors in front of Sardi's until about two in the morning. And when I was leaving, he'd always say, "Here, let me give you subway money to go." He thought that I was walking because I couldn't afford to take the subway, and he didn't want me to get mugged. I would always have to convince him that I was walking by choice, and that it was going to be all right. Here's this poor man with shoes falling off his feet, trying to give me money so I'd be OK. Most of these people aren't around anymore.

And it's sad, because the Hinckleys and the Chapmans and people like that have given a bad name to fans, because they were so obsessed. Yes, we're all obsessed a little bit, but I never met any fan that I can remember where I thought, "Ooh, that star has a problem here," you know, where a fan was so nuts over someone that I was listening to him thinking, "Ooh, hmm..." It was more just of the moment, and you'd have your favorite, who you'd put a little bit more energy out for, but most of the time you would be very knowledgeable about everybody. And even now there seems to be one person I know in every city who knows everybody—from stars to politicians to songwriters to producers—they are just on it.

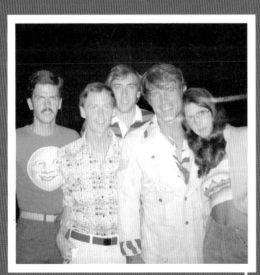

Scott Weaver, Gary Boas, Donald Myer, and Dana Desmond with Robert Conrad
at the *Mike Douglas Show*
Philadelphia, PA
n.d.

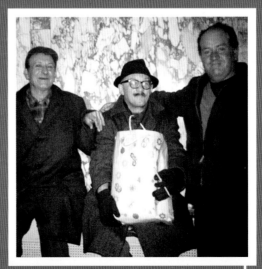

John "Pops", Unidentified Fan and "Good Humor Man" David
at the *Tony Awards* party
Americana Hotel, New York City
Sunday March 28th, 1971

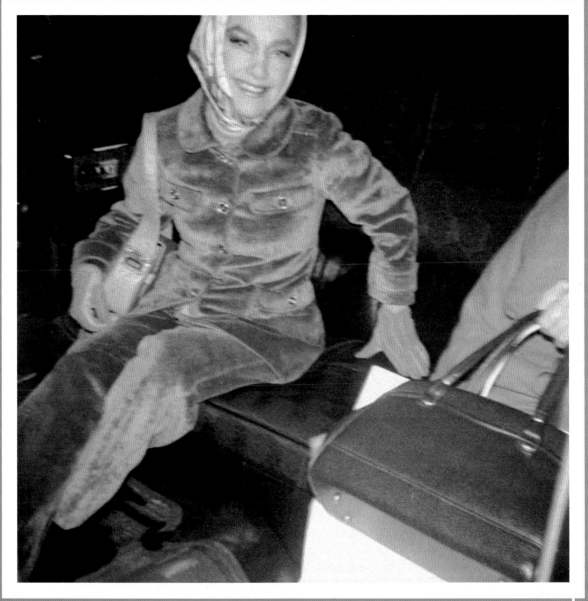

Anne Baxter
in *Applause*
Palace Theatre, New York City
Friday, February 11th, 1972

Paul Williams
at the *Tonight Show*
New York City
Wednesday, November 15th, 1972

Cab Calloway
at the *David Frost Show*
New York City
n.d

Lou Rawls
at the *David Frost Show*
New York City
Tuesday, April 25th, 1972

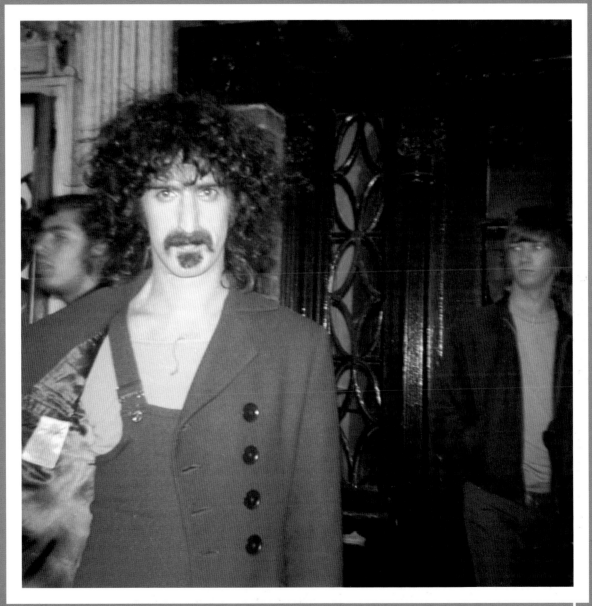

Frank Zappa
at the *David Frost Show*
New York City
Friday, September 24th, 1971

Dennis Hopper
at the *David Frost Show*
New York City
Friday, September 24th, 1971

Janet Leigh
outside the *Bob Hope Flood Relief Telethon*
Baltimore Hilton, Baltimore, MD
Saturday, July 22nd, 1972

James Stewart
outside the *Bob Hope Flood Relief Telethon*
Baltimore Hilton, Baltimore, MD
Saturday, July 22nd, 1972

Julie Andrews
at the University of Maryland
College Park, MD
Saturday, June 6th, 1970

Sophia Loren
at the *David Frost Show*
New York City
Wednesday, September 22nd, 1970

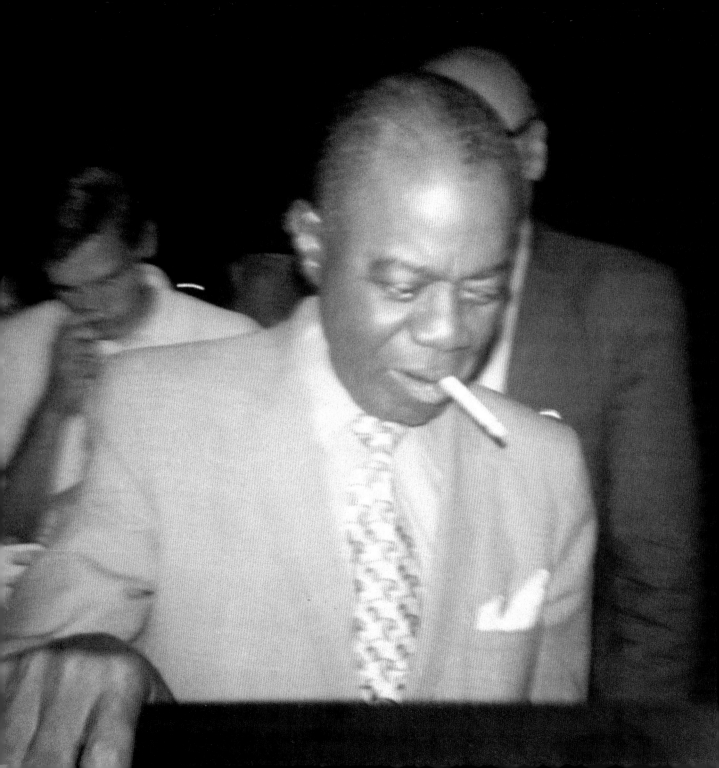

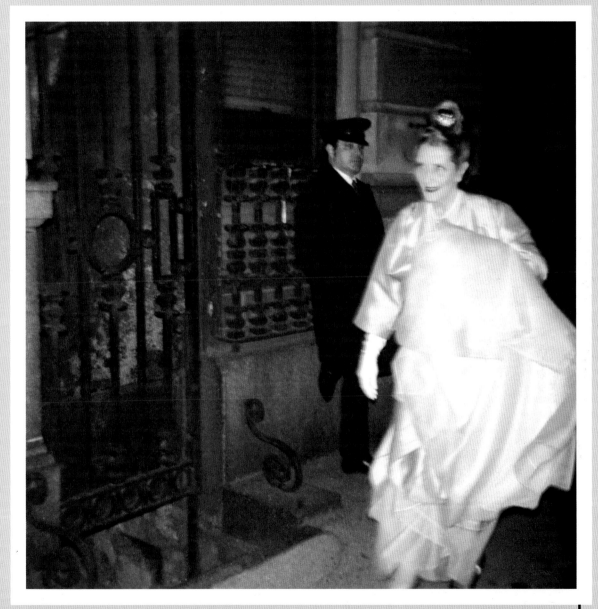

Louis Armstrong
at the Ed Sullivan Theatre
New York City
Sunday, April 28th, 1968

Lynn Fontanne
at the *Tony Awards*
Mark Hellinger Theatre, New York City
Sunday, April 19th, 1970

on
broadway

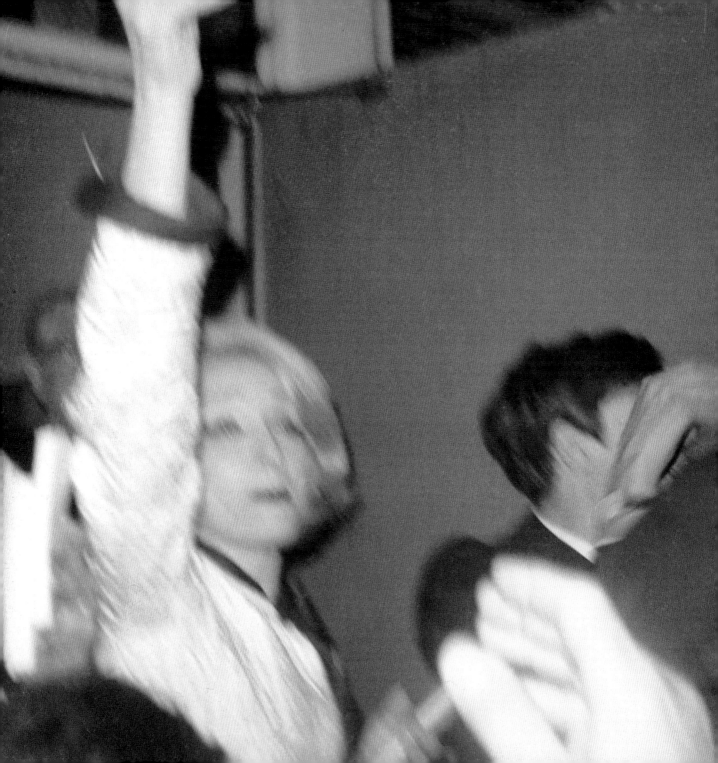

Marlene Dietrich
outside *The Marlene Dietrich Review*
Lunt-Fontanne Theatre, New York City
Saturday, October 28th, 1967

This woman was still out singing when she was in her seventies. In '67, she was performing *The Marlene Dietrich Review* on Broadway, with Burt Bacharach accompanying her on piano. They would have to block off the streets with cops on horses and everything. I mean, it was pandemonium. They would hoist her on top of the limousine, and she would throw out little postcard size pictures of herself and blow kisses. It was the ultimate of glamour. There were a good three hundred people crowded around the car. They would lower her down through the hole in the roof.

Ten years later, I saw her again when she was still touring in the same show, except this time, instead of playing Broadway houses, she was at Playhouse in the Park in Philly. I'd heard that if you spoke German to her or brought her a gift it was easier to get her to talk to you. My mother was an Avon lady, so I wrapped up some perfume that she had around, a sample. I approached her with the gift. It got her attention. She never opened it in front of me—I mean, God knows what she would do with it—but she took it and thanked me, and then I had her attention, and I had her sign the things I had. I didn't have much on me. Like I said, back then I didn't do my homework because I was a victim of television. I had no idea who these legends were, like Marlene Dietrich, Paulette Goddard, Joan Bennett. Only later did I realize I gave the sex goddess of the world a free sample of 'Here's My Heart' cologne.

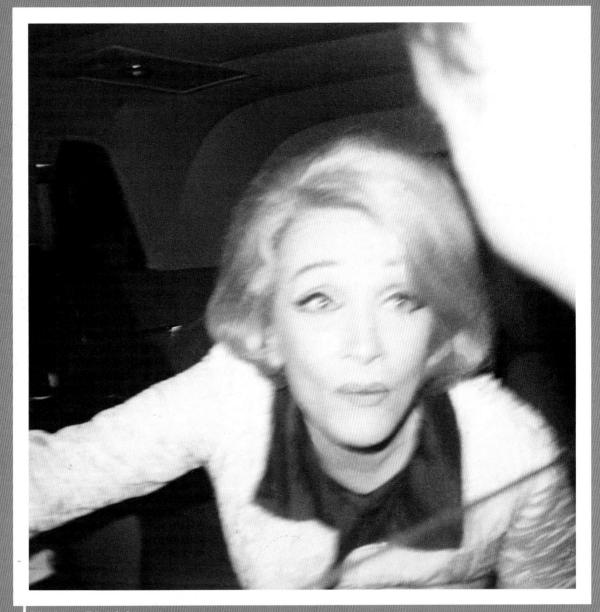

Marlene Dietrich
outside *The Marlene Dietrich Review*
Lunt-Fontanne Theatre, New York City
Saturday, October 28th, 1967

David Bowie
at the *Grammy Awards*
New York City
Saturday, March 1st, 1975

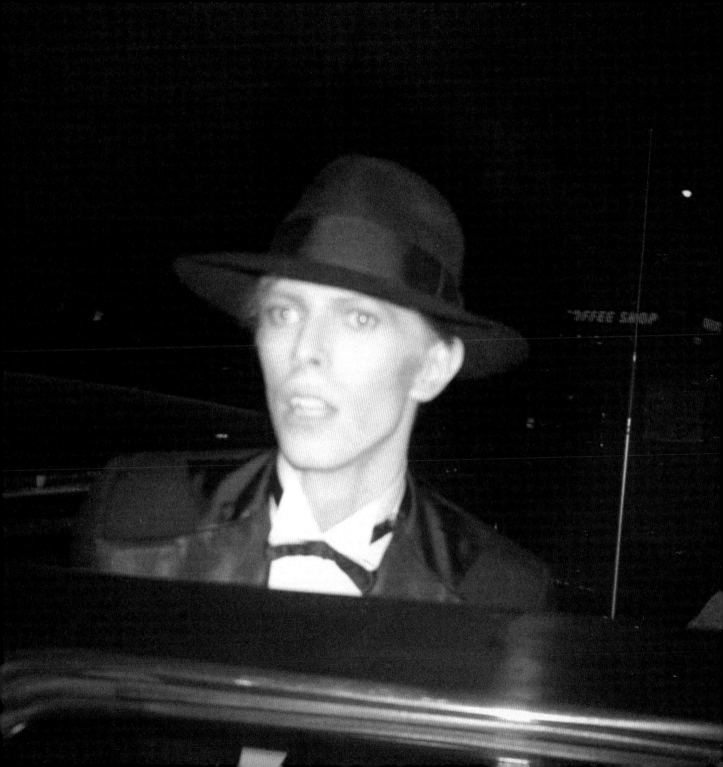

Peter Falk
in *The Prisoner of Second Avenue*
Eugene O'Neill Theatre, New York City
Thursday, November 11th, 1971

Diana Rigg
in *Abelard and Heloise*
Brooks Atkinson Theatre, New York City
Thursday, April 1st, 1971

Agnes Moorehead
in *Gigi*
Uris Theatre, New York City
Thursday, November 20th, 1973

Vivian Vance
in *My Daughter, Your Son*
Booth Theatre, New York City
Thursday, June 3rd, 1969

Vincent Price
reading *Dear Theo*
Millersville State College, Millersville, PA
Thursday, February 6th, 1969

Zsa Zsa Gabor
in *Forty Carats*
Morosco Theatre, New York City
Wednesday, July 29th, 1970

Pearl Bailey
in *Forty Carats*
Morosco Theatre, New York City
Wednesday, July 29th, 1970

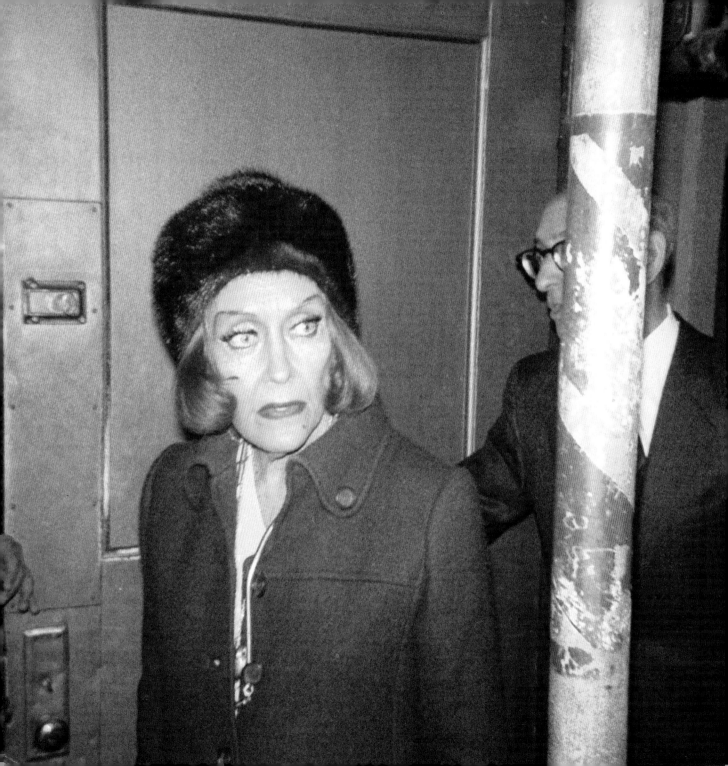

Gloria Swanson
in *Butterflies are Free*
Booth Theatre, New York City
Saturday, November 27th, 1971

Here, in the picture below, she was at the Landis Valley Motor Inn. She was in Lancaster as a guest speaker at some kind of luncheon. The whole time she was talking to me she was saying how I was eating too much sugar, and she kept hitting me in the chest with her carnation; she always carried a carnation for some reason. She was so intense that she would point out other people's flaws to try to help them. It wasn't a judgmental statement but more of a helpful statement—like, "You eat too much sugar. I can tell, I can see it in your eyes and in your face." And it was true, I did eat a lot of sugar. I saw her five times and I'd say she brought it up three.

I used to get nervous back then when I approached people for these photos, because I didn't know what the response would be. Before I was hidden behind the camera, but this was a time now where it would be me and them in the same picture. When I was getting an autograph it was a different encounter. Now it was me asking to have a photo with them, which I knew I was going to cherish because I was being captured on film with them. And Gloria said yes, and we took the picture. And I had one of the photos enlarged, and I sent it to her to sign. I had a piece of cardboard with it, and she sent the picture back, and on the cardboard she wrote, "Would you please sign and send me one of these too? Love, GS." So I sent her a picture of her with *my* autograph, and I was thinking, I wonder what she did with it? She must have a thousand pictures of herself, and why would she want my autograph? I wonder what she did with it?

Gary Boas with Gloria Swanson
at the Landis Valley Motor Inn
Lancaster, PA
n.d.

Keir Dullea
in *Butterflies Are Free*
Booth Theatre, New York City
Saturday, December 13, 1969

Jerry Orbach
in *Promises, Promises*
Shubert Theatre, New York City
Saturday, April 26th, 1969

Blythe Danner
in *Butterflies Are Free*
Booth Theatre, New York City
Saturday, December 13, 1969

Bruce Dern
at the Sherry Netherland Hotel
New York City
Saturday, September 25th, 1976

Gary Boas with Diane Ladd
in *Lu Ann Hampton Laverty Oberlander*
Booth Theatre, New York City
n.d.

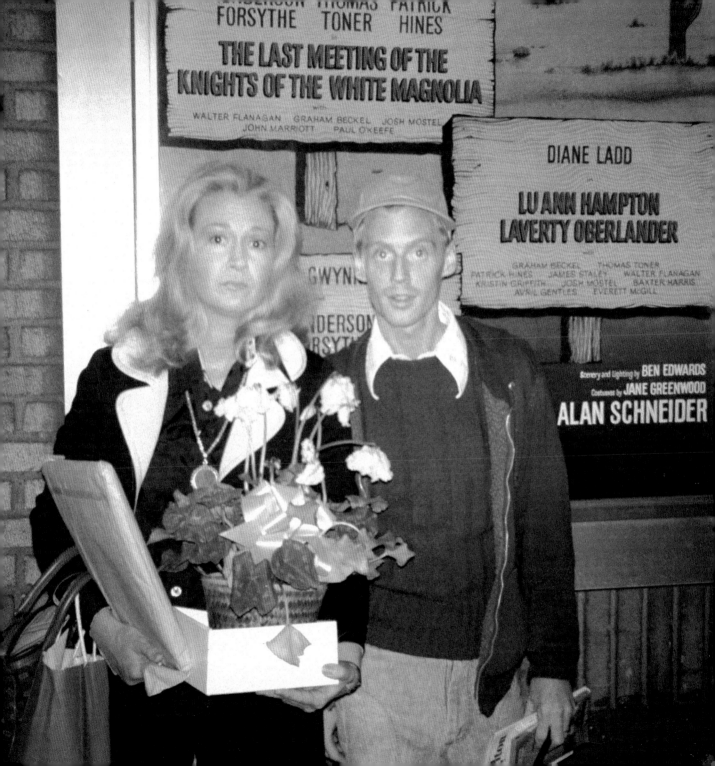

Katharine Hepburn
in *Coco*
Mark Hellinger Theatre, New York City
Saturday, December 13th, 1969

Katharine Hepburn
in *Coco*
Mark Hellinger Theatre, New York City
Saturday, January 31st, 1970

I had a debate with her in 1976... we made a pact. She said, "If you never take a picture of me again unless somebody else is already taking one, we will be on good terms; but if you do, you know how I hate it." Now my whole goal back then was to get a picture taken with her—and one with Laurence Olivier. I told her that, and she said, "Well, I can't help you, because I don't do that. If I would do it for one, I'd have to do it for everybody."

So she came out of the stage door while she was doing a play in Philly, and this one woman next to me started getting trigger-happy and I thought she was going to shoot the shot. I had my camera up, ready to go, and at the last second she chickened out, and I—I shot. And Katharine turned around, and in front of this whole group of fans, she said to me, "There's nothing I'd like to do more than come over there and give you a punch right now."

Well, I was devastated. I just crumbled and went home. For days after that, I hid in doorways like Eve Harrington, watching her go in and out. I was eager to see her, but miserable, and afraid for her to see me. Finally, her chauffeur Fisher says to me, "You've really got to talk to her, because there's another guy who was actually following her jogging, hanging out in front of the hotel, and she mistook you for him; and she mentioned later that she felt bad because she knew there was a mistake." She knew my approach was different than his: he was relentless, I wasn't.

The play was closing that weekend, and so at the Saturday matinee I stood there waiting. I told her, "I'm really sorry for the other night," and I explained it to her, and she said, "OK, I figured as much." I said, "I just don't understand one thing: right now you're on the cover of *Life* magazine and *Time*—why won't you let a fan photograph you when you'll let magazines photograph you?"

And she explained to me that when you do movie deals, that's all part of the publicity—you have to agree to do that at the beginning whether you like it or not. So she wasn't doing it because she wanted to. She explained that, and I understood, and after that she and I had a very good rapport.

This was one of several encounters that began in 1968 and dropped off around 1996 when she moved to Connecticut and became a total recluse. I went to her house numerous times when she lived in New York. I'd always try to find an excuse to drop something off, like a pie or a cake, just as a gesture, because I read that she was a freak for sweets. Most of the time her secretary Phyllis would answer, but there were times when she would answer the door herself. She was a little put out that I had the nerve to come to the door, but once she saw I was there just to deliver her a present and not to ask for an autograph, she was receptive. And I would always get a thank-you note for the pie. I have around 13 personal letters from her, in addition to Christmas cards and Birthday cards and extremely rare personally dedicated 8x10 photos.

Gary Boas with Laurence Olivier
outside the Wyndham Hotel
New York City
n.d.

André Previn
at *Coco*
Mark Hellinger Theatre, New York City
Saturday, December 13th, 1969

Marcel Marceau
at the *Dr. Joyce Brothers Show*
New York City
Thursday, April 19th, 1973

Eileen Herlie
in *Emperor Henry 10th*
Ethel Barrymore Theatre, New York City
Saturday, April 7th, 1973

Jacqueline Bisset
on the set of *Speed Is of the Essence*
New York City
Monday, November 30th, 1970

illian Gish
Uncle Vanya
oseph E. Levine Theatre, New York City
onday, July 23rd, 1973

Dustin Hoffman
in *Jimmy Shine*
Forrest Theatre, Philadelphia, PA
Saturday, October 26th, 1968

Anne Bancroft
in *A Cry of Players*
Vivian Beaumont Theatre, New York City
Saturday, October 19th, 1968

Chita Rivera
in *Chicago*
46th Street Theatre, New York City
n.d.

Chita is the ultimate Broadway star. I admire her stamina. It's hard to think of anybody who's won more Tonys than she has; she's theater to the hilt. She's so beautiful and so charming, and whatever you saw her in, you knew you were always going to see a good show. Even if what she was in was bad, she always outshined it with her performance.

It took her quite a few years before she recognized me. I was waiting for her outside the stage door of the Martin Beck Theater in New York. Apparently she wasn't going to come out in between shows because they were having trouble with the play. But the doorman called us in... there were about three of us waiting for her, and we filed into the hallway outside her dressing room. She was standing at the door signing each one of our autographs, and when she was signing mine she looked up at me like she was trying to place my face, and finally she said, "Who *are* you? My God... I see you everywhere!" Then I explained to her that I'd been following her since the late sixties and I'd seen her outside all of the talk shows—the *Mike Douglas Show* and the *Ed Sullivan Show*—and then also at the Valley Forge Music Fair. She was totally amazed, like it all started falling together. When I told her I was from Lancaster, she was floored. It was like, "How does somebody from there do what you do?" And we had a good chat.

This was during the mid-seventies, and she was on Broadway a lot after that so I would see her frequently, and every time she would acknowledge me and remember my name. Over the years it grew to "Hi," a hug, a kiss, and standing around and chatting when we could. It's nice to be acknowledged by anyone who has talent who you greatly admire. The fact that I feel there was a connection made somewhere—the fact that you can share that moment with that person and have that connection outside that moment—is a very meaningful thing for a fan.

After seeing so many of her friends sell out to Hollywood and she's still hitting the boards—I wonder what ever kept her from selling out. But she hasn't. You can't sell out on Broadway. If you're in it for the money and the fame, go on to Hollywood, that's your shortcut. Chita's a true entertainer, in my eyes.

Gary Boas with Rosalind Russell
at the Waldorf Astoria Towers
New York City
n.d.

Angela Lansbury
outside *Sweeney Todd*
Uris Theatre, New York City
Sunday, June 3rd, 1979

Ann Miller
in *Sugar Babies*
Mark Hellinger Theatre, New York City
Saturday, December 15th, 1979

John Gielgud
in *No Man's Land*
Longacre Theatre, New York City
Monday, November 8th, 1976

Gary Boas with Henry Fonda
in *Monday in October*
Royale Theatre, New York City
Saturday, October 21st, 1978

Jeff Conaway
in *Grease*
Eden Theatre, New York City
Saturday, April 29th, 1972

Deborah Kerr
at the *Tony Awards*
Hilton Hotel, New York City
n.d.

Yul Brynner
in *The King and I*
Valley Forge Music Fair, Devon, PA
Thursday, September 16th, 1976

Gary Boas with Ingrid Bergman
in *Captain Brassbound's Conversation*
Playhouse Theatre, Wilmington, DE
Saturday, March 11th, 1972

Tony Curtis
in a rehearsal for *Turtleneck*
New York City
Wednesday, July 25th, 1973

Jack Palance
at the Holiday Inn
Lancaster, PA
n.d.

Geraldine Page
in *Absurd Person, Singular*
Music Box Theatre, New York City
n.d.

127

She was one of the neatest ladies. When I was fifteen I had no idea who she was; all I knew is I would spend time going to certain stage doors, and that's who I was getting. She was playing at the Ethel Barrymore Theatre in a play called *Black Comedy.* I didn't really know her work, I just knew the name. I was waiting outside between a matinee and an evening show, and she apparently wasn't coming out, and I didn't know this and I kept waiting. The doorman must have told her someone was waiting for her to sign a program, and she invited me and my mother right into her dressing room. I can still see the amazement on my mother's face. This was the first time we'd been to a dressing room of a star, and it was decorated to the hilt. There were telegrams, flowers, a changing screen, lightbulbs all around the mirror, little personal trinkets to make it seem like home... and she was one of those actresses who still put the red dots in the corner of her eyes, so that when people saw you from the back row, it didn't look like you had only one eye. So she had these intense red dots right in the corner of her eyes, these big false eyelashes and this big hair, and she was just overly sweet. Again, having no idea of the caliber of her stardom, I didn't realize that she was one of Tennessee Williams's favorite actresses. She did practically all of his plays on Broadway at one time or another. But she was definitely a theatrical actress. She was great on screen once she got the role, but she didn't have the name to carry a film.

Years later she came to Lancaster: they were filming a movie about Mennonites called *Rachel's People*, which she starred in as the Mennonite mother. I just had to work on this film, I had to somehow get involved, this was movie stars in my own backyard. So I was basically Geraldine Page's stand-in, because I was her height. When they were shooting other people's scenes she and I would hang

Gary Boas with Geraldine Page
in *Absurd Person, Singular*
Music Box Theatre, New York City
n.d.

out and just talk and talk and talk and talk. I refreshed her memory about Broadway and how I originally met her. When I finally brought out the picture I took of her in the dressing room, she flashed back and remembered that day—it was about eight years before—and she just freaked. That just sealed the envelope for us as friends. They had a night off during filming, and I talked her into going to see some friends of mine at the local theater in *A Funny Thing Happened on the Way to the Forum*. We got second row, and all of my friends on stage saw that I was in the audience with Geraldine Page, and then I brought her backstage to meet people, and I was eating it up. Then she came to my house afterwards and my mother made spaghetti. It was weird, our lives intertwined so much, and because she did so much theater I would get to see her frequently.

When she played that role in *The Trip to Bountiful*, that role was her—a little old lady with a mischievous giggle. She was so down to earth every time you would talk to her... and she was one I could say was truly my friend. Every time she saw me there was always an embrace and a kiss and a hug and chatting, and it was hard for me to keep believing she was who she was. When she won the Oscar, I remember she was so humble about it and wouldn't have cared if she'd won it or not—but it was such a long time coming.

I really miss her... we had so many neat chats. She made me laugh because she was just so down to earth, and she'd always dress like an old hippie—she would be so unpretentious with her outfits. She'd wear gauze blouses and jeans and this ratty old coat that looked like it was from a thrift store; she was borderline looking like a bum. If I didn't know who she was, I'd think she might be a bag lady... she was always dragging paper bags around with her. And there was a wig she would wear that looked like it had been thrown in the corner, and she'd just shake it and put it on and think she looked delightful, and she would wear no bra. She just didn't care. She was untouched by the whole stardom thing. It was almost like she was embarrassed about the recognition of the great work she did. As a person she was almost backward, but when she was on stage her performances were so incredibly powerful.

She always made me feel like an equal. There was never this star-fan thing in the way; there was never this huge separation of levels. It was more like being in a local play with her, and she was the lead and I was in the chorus. She made my friends feel welcome because they were friends of mine. She made me realize that the pictures I was taking were more than just photographs in a collection: I was capturing real moments with real meaning. Up until then I was just producing pictures. Now I was making a memory, and the photo was serving as a trigger for the memory. I had more faith that real relationships could happen between celebrities and fans because of this.

She had always asked me to put together all of the photos I'd taken of her throughout the years. It took me forever but I finally did it, and I took it with me to meet her backstage when she was doing *Blithe Spirit* on Broadway. I had made an album of every picture I'd ever taken of her or devoted to her. I had a friend who knew calligraphy, and I had him write my dedication in the front. She had no idea she was getting it. And I had been waiting by the stage door for her to come in, but she never showed up; the stand-in had to go on in her place. I found out later that she had suddenly died that day. Tears still come to my eyes every time I think about it, or even when I think about her. I get all choked up because I feel so lucky that at least I knew her... I wish more people knew about her and her work.

Geraldine Page
in *Black Comedy*
Ethel Barrymore Theatre, New York City
Saturday, October 28th, 1967

Raul Julia and Clifton Davis
in *Two Gentlemen of Verona*
St. James Theatre, New York City
Saturday, February 12th, 1972

Danny Aiello
in *Knockout*
Helen Hayes Theatre, New York City
Friday, August 31st, 1979

Kevin Kline and Patti LuPone
in *Loose Ends*
Circle in the Square Theatre, New York City
Sunday, January 29th, 1980

Faye Dunaway
at *No Man's Land*
Longacre Theatre, New York City
February, 1977

Martin S
in *Death of a Sale*
Joseph E. Levine Theatre, New Yo
Monday, August 4

Steve McQueen and Ali MacGraw
at *A Chorus Line*
Shubert Theatre, New York City
n.d.

Anthony Ho
in
Plymouth Theatre, New Yo
Saturday, May 31

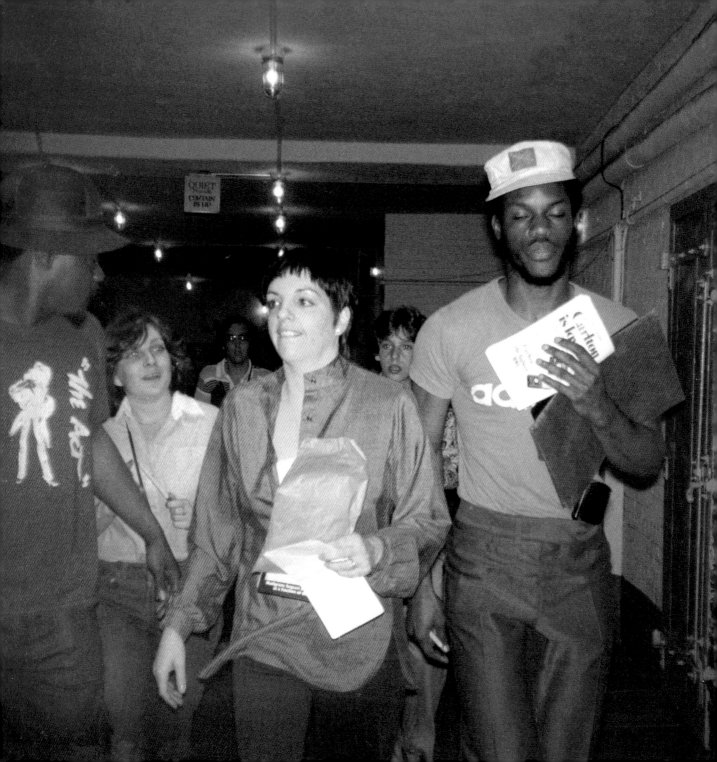

Liza Minnelli
in *The Act*
Majestic Theatre, New York City
Saturday, June 4th, 1978

Liza. She was just reeking of fame and glory. She was running the gamut at the time: Broadway, TV, movies, records, she was Judy Garland's daughter, Vincente Minnelli's daughter... and she was constantly in a whirlwind. She just seemed to fit into the mold of everything that was going on in the seventies. She was every fag's idol—and if you didn't love Liza, you loved Judy; there was always a connection.

She was always scatterbrained in person, very jumpy; almost like she was short-wired. She was just so full of life, and that was what everybody came to see. A big part of her performance was her high-energy stage presence.

She's one also, when she saw you around a lot, who definitely made it a point to acknowledge a special hello, like, "Yeah, you were at so-and-so last week...," so there was always some eye contact. There are certain stars who do that, because they see you around a lot; but they don't just start chatting with you because there's really nothing to talk about, since you don't really know them—although you sort of know them.

It was really after she did *Cabaret* that she got into that whole craziness of Studio 54. I'd often photograph her going in there. She was definitely one who was spending time in the basement. Obviously, because it was the times, I'm sure there were a lot of ups, downs, drinks, whatever. She'd do a Broadway show and then she'd go out to Studio 54 and stay all night long. One evening, I had left the club at 4:00 in the morning, and she was still there. This photo is her, showing up for a Broadway matinee at the Majestic that same day.

For some reason there were these two black guys who showed up every day to escort her in; I think they were two neighborhood people she gave money to who acted like her assistants. She would come in like twenty minutes before the show, half-dressed with her shirt unbuttoned. It seemed like she would throw on clothes that had been lying on the floor, get to the stage door of the theater and then, literally minutes later, she'd be on stage dressed in full costume and makeup, with this dynamic energy that entertained you from the minute she walked on to the minute she walked out. If you were just somebody who bought a ticket and didn't know she was at Studio 54 all night, you'd never guess it. It didn't effect her performance. God knows where she got the energy, but she was *on*.

Carl Reiner
at *Broadway for Peace 1968*
New York Philharmonic, New York City
Sunday, January 2oth, 1968

Jon Voight
at an unidentified hotel
New York City
n.d.

Rex Reed
at the opening night of *Little Black Book*
Helen Hayes Theatre, New York City
Tuesday, April 25th, 1972

**Gary Boas with Merle Oberon
and Robert Wolders**
at the Royal Theatre
New York City
n.d.

Maureen Stapleton
in *The Secret Affairs of Mildred Wilde*
Plymouth Theatre, New York City
n.d.

Tennessee Williams
at a function
New York City
n.d.

awards
and
events

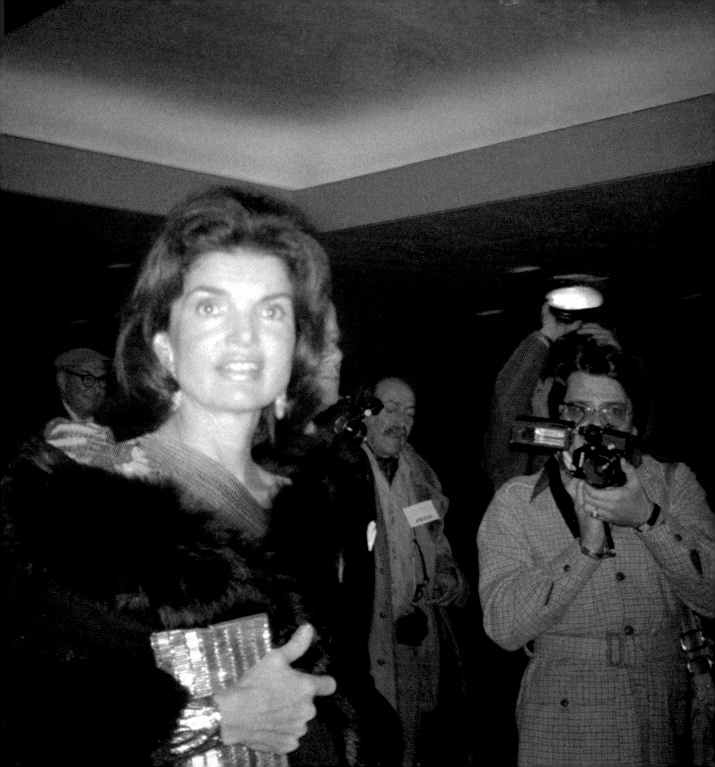

Jacqueline Kennedy Onassis
in the parking garage at the Metropolitan Opera House
New York City
n.d.

There have been few people in my lifetime who actually commanded a room when they entered it, and she was one of them. She was our queen. I was very lucky to collect in the period of time when she was around. She always attended everything Kennedy-oriented.

I got Rose, Ted, and Robert Kennedy, but for some reason Jackie would never sign. She was very mechanical, almost like a Stepford Wife. She wouldn't look to the left or right, and she never really acknowledged my presence or anyone outside her immediate group. She and her kids never signed anything back then. I only asked her for an autograph once, then I realized she was unapproachable.

I was waiting in front of her apartment on Fifth Avenue while she was at a ballet. All the way there I was really nervous. We'd jumped in the car once we knew she was leaving and flew up the street right before she got there—I had butterflies in my stomach. By the time I got situated, she got out of her car. I approached her—it all happened so fast, I didn't even have time to think about it, which was better... there's nothing worse than waiting six hours and then getting turned down. And that's what she did: "No, thank you," she said, and walked right by me... she never went out of her way to avoid photographers, but she never made eye contact. If you were beyond the crowd she was with, she didn't know you existed. To me, though, it didn't really matter—it was like getting that close to royalty.

Gary Boas with
Jacqueline Kennedy Onassis
outside her apartment
New York City
Sunday, November 7th, 1976

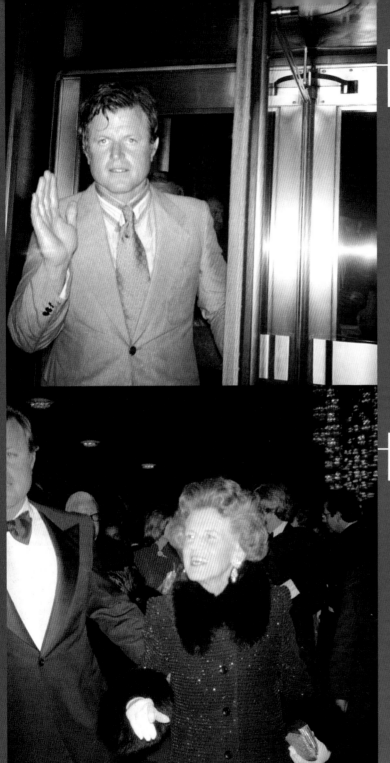

Ted Kennedy
at a reception for the
Robert F. Kennedy Tennis Tournament
NBC Building, New York City
Friday, August 25th, 1978

Rose Kennedy
at Kennedy Center
Washington, D.C.
circa 1979

Joan Kennedy
at a reception for the
Robert F. Kennedy Tennis Tournament
NBC Building, New York City
Friday, August 24th, 1979

Bianca Jagger and Andy Warhol
New York City
n.d.

John F. Kennedy Jr.
at a reception for the
Robert F. Kennedy Tennis Tournament
NBC Building, New York City
Friday, August 25th, 1978

Peter Berlin
on the street
New York City
n.d.

Monique van Vooren
at a party
Hilton Hotel, New York City
Sunday, April 30th, 1978

Sylvia Miles
at the premiere of *Cabaret*
The Ziegfield Theatre, New York City
Sunday, February 13th, 1972

Divine
at the premiere of *Tommy*
New York City
Tuesday, March 18th, 1975

Elton John
at the premiere of *Tommy*
New York City
Tuesday, March 18th, 1975

Carly Simon and James Taylor
at a reception for the *Robert F. Kennedy Tennis Tournament*
NBC Building, New York City
Friday, August 25th, 1978

John Lennon and Yoko Ono
at the *Grammy Awards*
New York City
Saturday, March 1st, 1975

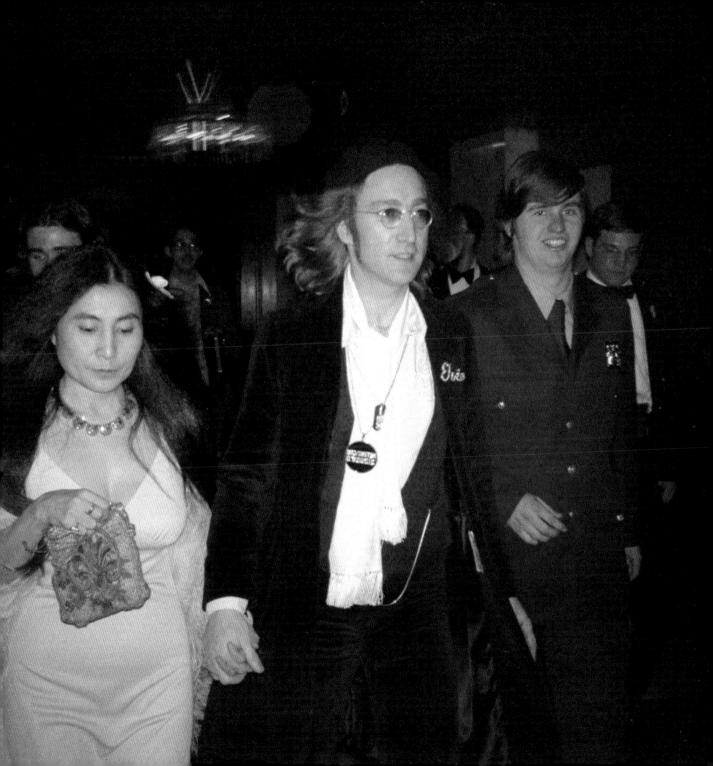

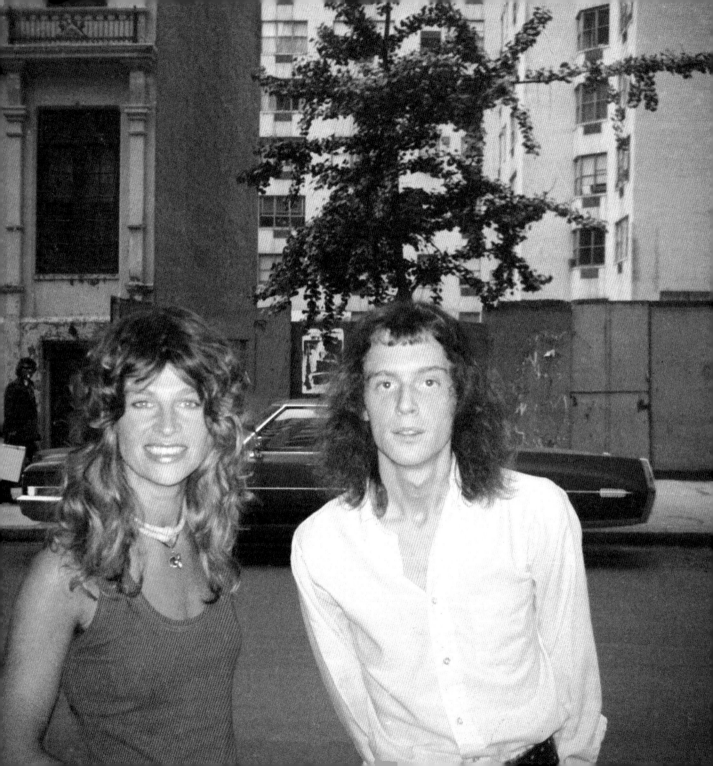

Gary Boas with Julie Christie
outside the Carlyle Hotel
New York City
Thursday, June 15th, 1972

Something about Julie Christie just mesmerized me—the way she talked, the full lips... The first time I approached her and asked her to sign something was in 1972 at Madison Square Garden at a rally for George McGovern. It seemed like that whole little group she hung out with at the time was there: Warren Beatty, Jack Nicholson, Art Garfunkel, Goldie Hawn. And Beatty, her boyfriend then, was a big Democrat, so I assumed that was why she was at the rally.

One of the first things she asked me was what my astrological sign was, maybe trying to see what made me tick. Ironically, we were both Aries—our birthdays were two days apart—and she said, "That figures..." That's how we first connected.

I can't remember how it got from, "Here's a pen, here's a paper, sign it," to, "Oh, here's the phone number, call me up at the hotel." I don't even remember what purpose I would have had to call her—all I know is I did, and every day. Warren Beatty would answer every once in a while; sometimes she would answer; sometimes they weren't even there, and she would return my call. Once, I remember Warren answering and saying, "It's your friend Gary," and when she came on I was all tongue-tied, just thinking about him calling me her friend. I would stand outside the Carlyle for hours, trying to act all nonchalant, just to get a chance to see her. I have to admit I did get a little obsessed, because this was the first time I got this much personal attention from someone like that.

When she was doing *Uncle Vanya* on Broadway, she would invite me in to hang with her if I was outside the stage door when she was going in. I would sit in her dressing room and talk to her as she was sitting there in makeup, getting ready to go on. We hung out a lot. She even introduced me to her co-stars, Lillian Gish, George C. Scott, Kathleen Nesmith, and Nicol Williamson.

In the past, we corresponded frequently. I have several postcards and Christmas cards. Whenever I'd send her one, she'd always respond, and she would write in such a friendly way that when she sent a postcard once from the south of France—telling me that this was one of her most favorite places, and she was camping out in a van and stealing corn from local fields to eat—and then signed it "Love, Julie," I thought, "Julie who?" I could not think who I knew named Julie. I never guessed I would get something that personal from Julie Christie.

Gary Boas with Julie Christie
backstage at *Uncle Vanya*
Circle in the Square Theatre, New York City
n.d.

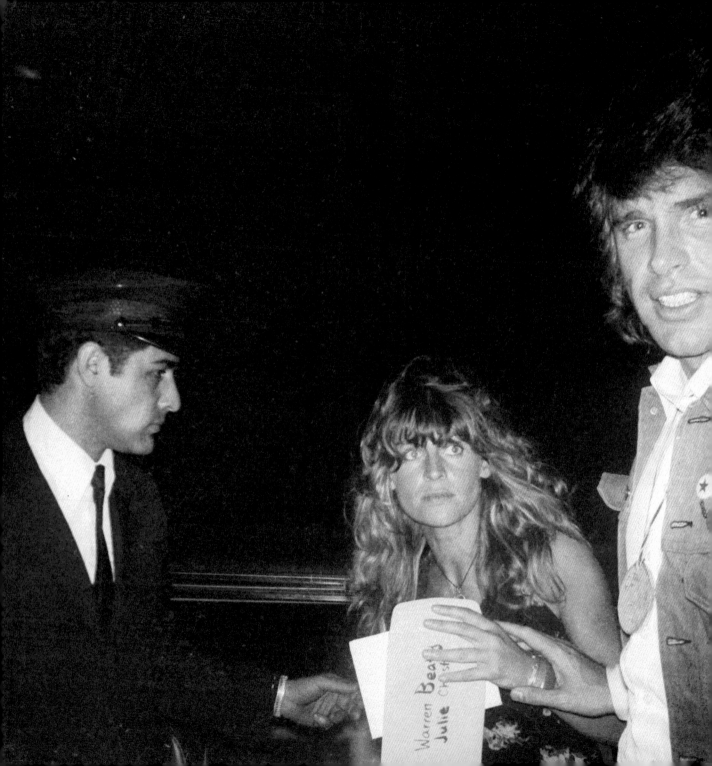

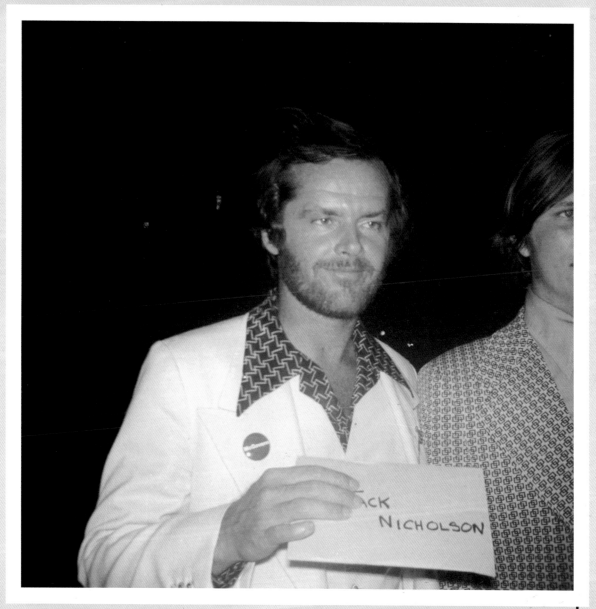

Jack Nicholson
at a party for George McGovern
Four Season's restaurant, New York City
Wednesday, June 14th, 1972

Julie Christie and Warren Beatty
at a party for George McGovern
Four Season's restaurant, New York City
Wednesday, June 14th, 1972

Ryan O'Neal
at a party for George McGovern
Four Season's restaurant, New York City
Wednesday, June 14th, 1972

Marlo Thomas
at the *George McGovern Rally*
Madison Square Garden, New York City
Wednesday, June 14th, 1972

Michael J. Pollard
at the *George McGovern Rally*
Madison Square Garden, New York City
Wednesday, June 14th, 1972

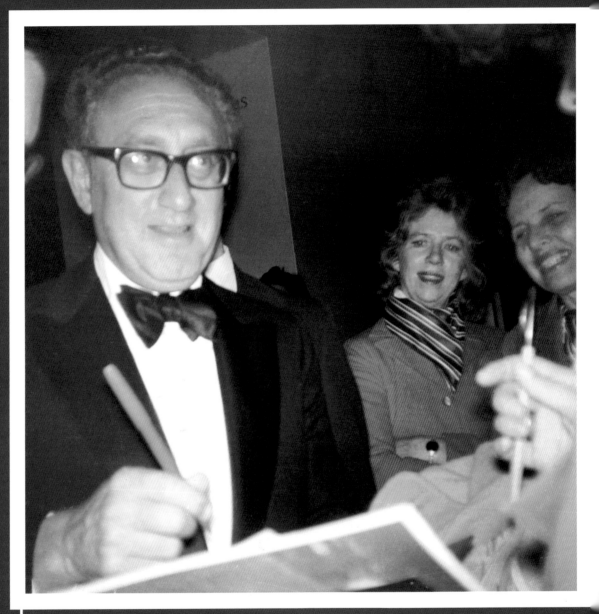

Henry Kissinger
at the American Film Institute
Kennedy Center, Washington, D.C.
Thursday, November 17th, 1977

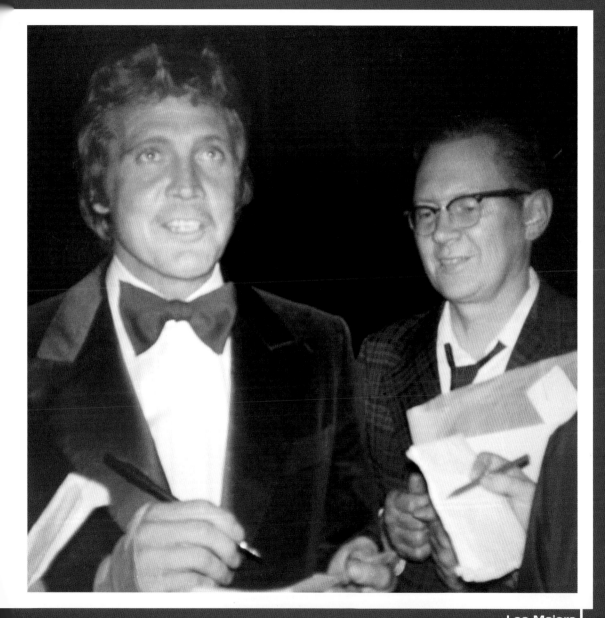

Lee Majors
at the American Film Institute
Kennedy Center, Washington, D.C.
Thursday, November 17th, 1977

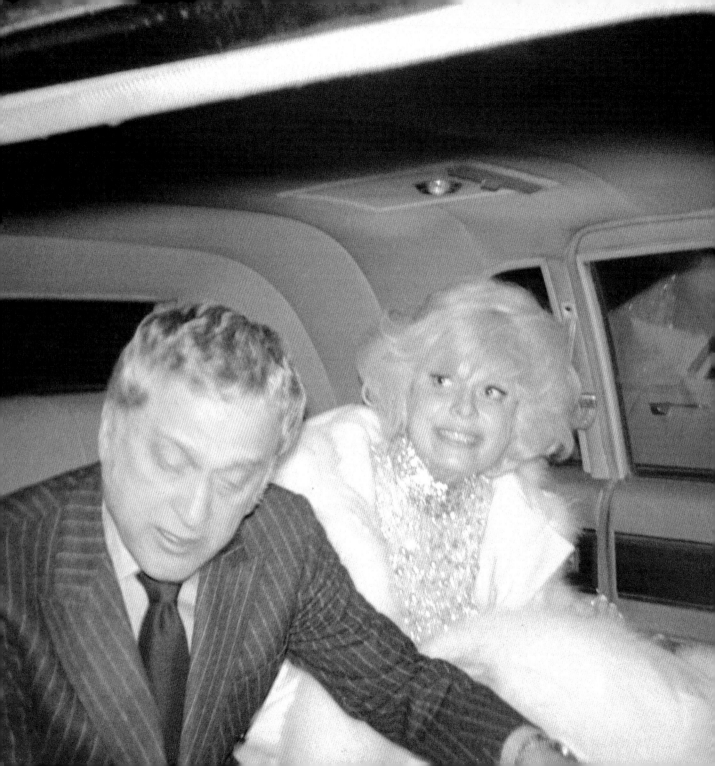

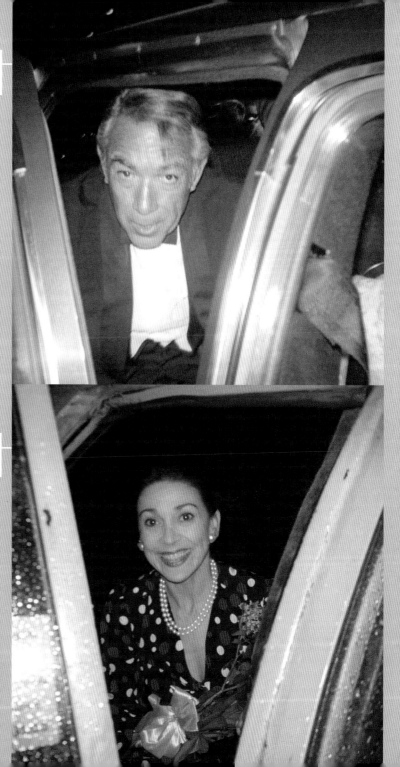

Anthony Quinn
at a reception for the *Tony Awards*
Americana Hotel, New York City
Sunday, March 28th, 1971

Margot Fonteyn
at a reception for the *Tony Awards*
Americana Hotel, New York City
Sunday, March 28th, 1971

Carol Channing
at the *Tony Awards*
New York City
n.d.

Marcello Mastroianni
at the *Dick Cavett Show*
New York City
n.d.

Gina Lollobr
outside the Plaza
New Yo

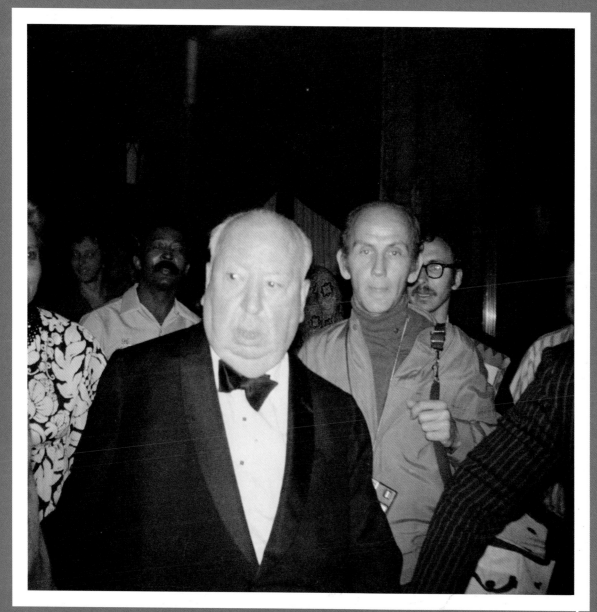

Alfred Hitchcock and Grace Kelly
at the *Hitchcock Gala*
Lincoln Center, New York City
Monday, April 29th, 1974

Alfred Hitchcock
at the *Hitchcock Gala*
Lincoln Center, New York City
Monday, April 29th, 1974

George Cukor
at a party in his honor
New York City
Sunday, April 30th, 1978

Ruth Gordon
outside Sardi's restaurant
New York City
n.d.

Anita Loos
at the Ethel Barrymore Theatre
New York City
Sunday, December 16th, 1979

Norman Lear
at a reception for the
Robert F. Kennedy Tennis Tournament
NBC Building, New York City
Friday, August 25th, 1978

Gary Boas with Carroll O'Connor
at a reception for the *Tony Awards*
Americana Hotel, New York City
Sunday, April 21st, 1974

Redd Foxx
at a party for Jimmy Carter
Kennedy Center, Washington, D.C.
Wednesday, January 19th, 1977

Jack Nicholson
at a party for Jimmy Carter
Kennedy Center, Washington, D.C.
Wednesday, January 19th, 1977

Billy Carter
at a party for Jimmy Carter
Kennedy Center, Washington, D.C.
Wednesday, January 19th, 1977

Loretta Lynn
at a party for Jimmy Carter
Kennedy Center, Washington, D.C.
Wednesday, January 19th, 1977

Walter Matthau
outside the *Tony Awards*
Mark Hellinger Theatre, New York City
Sunday, April 19th, 1970

Shirley MacLaine
outside the *Tony Awards*
Mark Hellinger Theatre, New York City
Sunday, April 19th, 1970

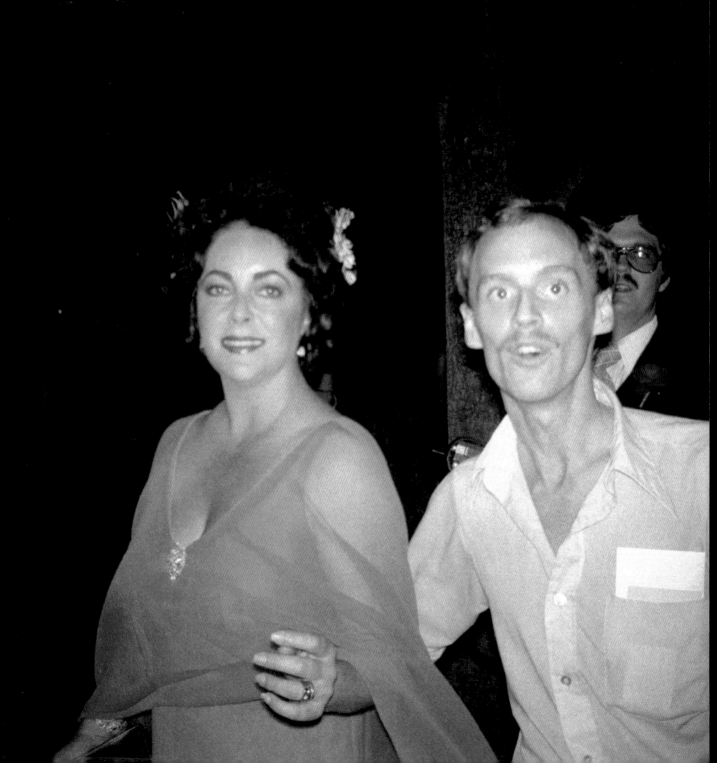

Gary Boas with Elizabeth Taylor
at Wolf Trap National Park for the Performing Arts
Vienna, VA
n.d.

Elizabeth Taylor was the goddess of the movie business for the era that I identified with. She was one of those people that you thought you would never see because she was so famous, but once I started seeing her, it seemed like I saw her about a thousand times. She was very approachable and very friendly. She would make eye contact, but even if you were the one she made eye contact with it was very hard to get her attention, because everyone was always pulling at her. Most of the situations I saw her in were not high-security situations, but she always had lots of hangers-on, making it difficult to get to her. The only time there was major security was when she was doing a Broadway show—then, everyone would show up to the point where they would actually have to block off the street.

She would never be able to cooperate with everybody and what they wanted. And it wasn't her, it was her entourage. The people around her created a problem, pulling and tugging like, "Oh, we're here to protect the star," and she never acted like that was what she wanted.

I think I actually spoke with her about sixty times. She was very childlike, very giddy. Sometimes I would see her dressed to the hilt, and other times I would see her with no makeup. Sometimes there were mood swings where I felt like I was meeting a completely different person. Once I waited two-and-a-half hours for her outside Elaine's restaurant. I'm freezing cold, and she comes out, and I'm holding my hand out for her to take the pen. This was a time when she was getting sick a lot. And she took the pen and looked at it, and said, "I can't deal with this. This isn't even open." And she didn't even hand the pen back to me. She just dropped it and walked off.

This photo was taken in Vienna, Virginia, when she was married to Senator Warner. It was on a lawn for a benefit at Wolf Trap, an outdoor Hollywood Bowl-type theater. Back then she was wearing those Halston tent dresses. She changed twice that night, almost like she was the one performing. One dress was red chiffon, one was blue chiffon; Halston designed those just for her.

It was time to go over for the performance; I think Baryshnikov was performing. She was starting to cross the lawn, and it was one of those disheveled moments where everyone forgot about her, and I was walking next to her getting ready to ask her to sign something. And suddenly she reached out and grabbed my arm, because she was sinking in her high heels into the grass.

She said, "Oh my God, I'm sinking." She was all sort of giddy. Just then the flash went off—it was my friend taking a picture of what was happening—and then, everybody suddenly realized where she was and quickly took her away from me.

Sidney Poitier and Joanna Shimkus
at the American Film Institute
Kennedy Center, Washington, D.C.
Thursday, November 17th, 1977

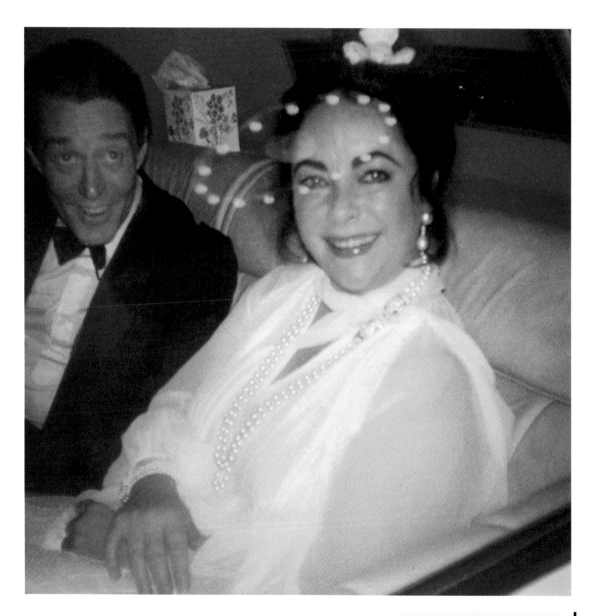

Elizabeth Taylor with Halston
at a party for Edith Head
Pierre Hotel, New York City
Tuesday, April 24th, 1979

Milton Berle
at the *George Burns and Walter Matthau Roast*
Americana Hotel, New York City
Thursday, April 10th, 1975

Buddy Hackett
at the *Robert F. Kennedy Tennis Tournament*
New York City
Friday, August 22nd, 1975

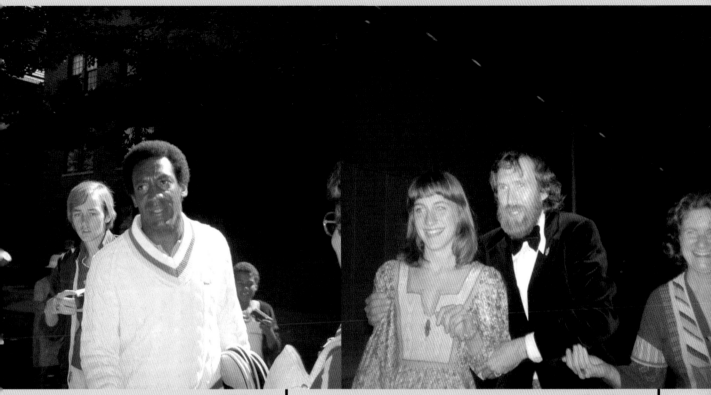

Bill Cosby
at the *Robert F. Kennedy Tennis Tournament*
New York City
Friday, August 25th, 1978

Jim Henson
at Bob Hope's birthday party
New York City
Thursday, May 25th, 1978

Gary Boas with Edgar Bergen, Charlie McCarthy and Mortimer
at the Host Farm Resort Hotel
Lancaster, PA
n.d.

Jeremy Black
filming *The Boys from Brazil*
Lancaster, PA
n.d.

Ricky Schroder
at a reception for the *Robert F. Kennedy Tennis Tournament*
NBC Building, New York City
Friday, August 25th, 1978

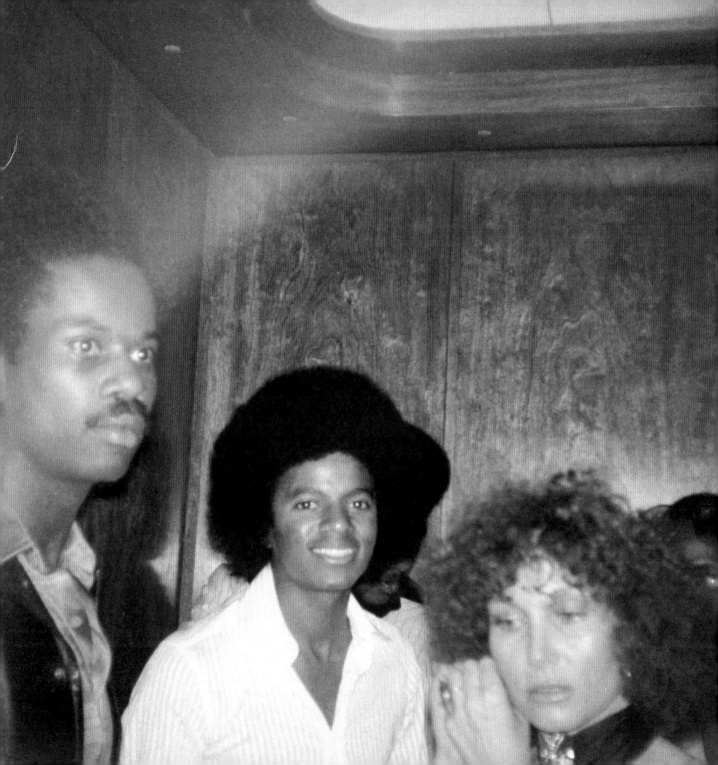

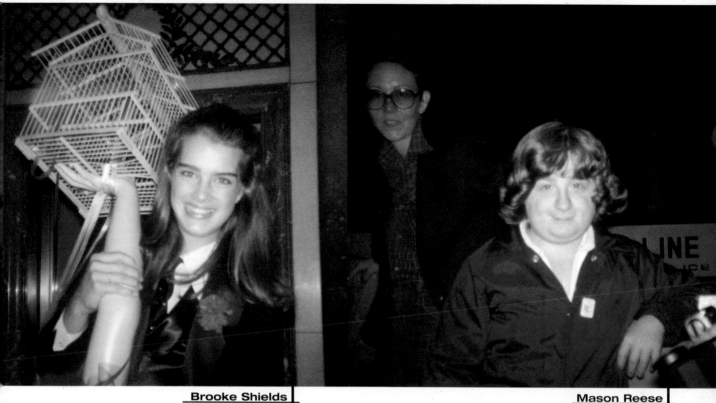

Brooke Shields
at a party for Edith Head
Pierre Hotel, New York City
Tuesday, April 24th, 1979

Mason Reese
in front of Sardi's restaurant
New York City
Sunday, June 3rd, 1979

Michael Jackson
at a reception for the *Robert F. Kennedy Tennis Tournament*
NBC Building, New York City
Friday, August 25th, 1978

He used to play the bathhouses a lot. He was the piano player for Bette Midler back in her Bathhouse Bette days. That's how he got discovered, through her, playing the bathhouses. I don't even remember him being there at the time—that would be like going to see Diana Ross and wondering who was playing guitar.

The bathhouses were open twenty-four hours and set up sort of like gyms. Even though you would never be able to spot them just by walking down the street, I could always sniff them out.

They had a room with little lockers you could rent; they had the sauna rooms, they had the steam rooms; they had the pool and the socializing room, which was basically a nearly pitch-black room with mattresses or exercise mats. All of the rooms in those places were really dark, but once you went to the same place a couple of times you knew where you were by the feel of things. There were also private rooms that were rented in eight-hour blocks, where a guy would be lying on a mattress with the door half-open, waiting for someone to drop in. At midnight on certain days they had a show in the big room. You didn't pay extra to see the singers—they were a bonus to lure you in, because there were so many bathhouses at the time. I would say 50 percent of the guys watching it were in towels; it was like being in Rome, in a Roman bath. And because most of these people were fag divas, the singers got all of the attention then—it wasn't like everyone was there trying to peek up each other's towels (although you could have frivolous sex and see Bette Midler all in the same night, in the same place). It was a fantasy come true for a fag—after all, this was the seventies.

Bette Midler
in *Clams on the Half Shell*
Philadelphia, PA
n.d.

Sonny Bono
at the *Mike Douglas Show*
Philadelphia, PA
Tuesday, June 10th, 1975

Cher and Gregg Allman
at a party for Jimmy Carter
Kennedy Center, Washington, D.C.
Wednesday, January 19th, 1977

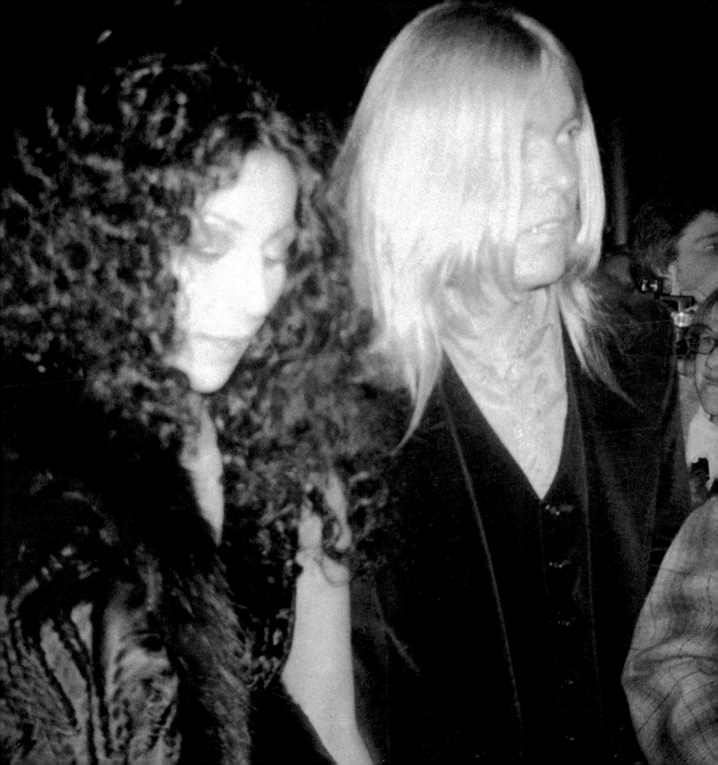

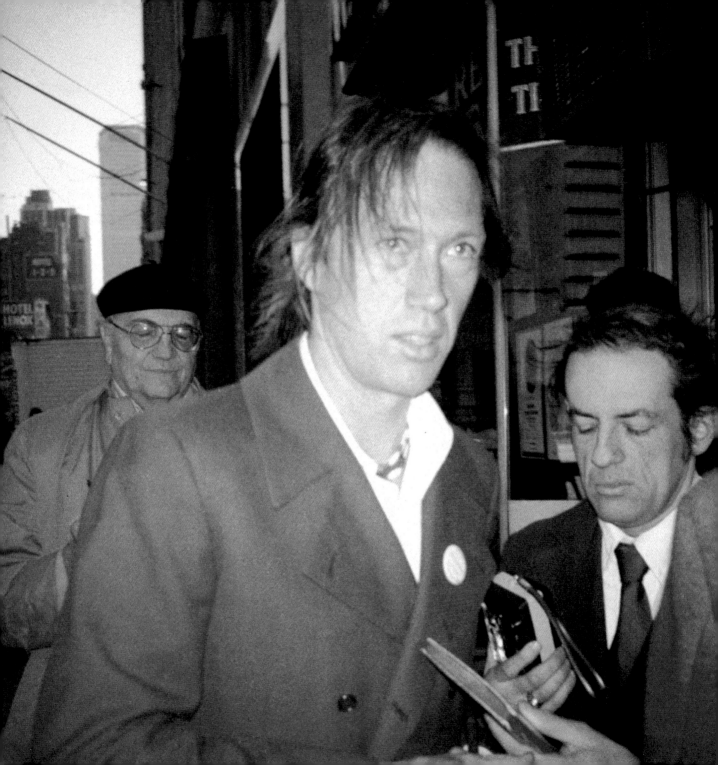

Peter Fonda
at the *Tonight Show*
New York City
Thursday, September 30th, 1971

Karen Black
at a reception for the *Tony Awards*
Americana Hotel, New York City
Sunday, April 21st, 1974

David Carradine
at the *Tony Awards*
Shubert Theatre, New York City
Sunday, April 21st, 1974

Glenn Close and Len Cariou
at a reception for the *Tony Awards*
Hilton Hotel, New York City
n.d.

Meryl Streep
at the *New York Film Critic's Awards*
Sardi's restaurant, New York City
Saturday, January 28th, 1978

Christopher Walken
at the *New York FIlm Critic's Awards*
Sardi's restaurant, New York City
Sunday, January 28th, 1979

Shirley Verrett
in the opera *Il Travatore*
Metropolitan Opera House, New York City
Saturday, November, 13th, 1971

Luciano Pavarotti
at the Metropolitan Opera House
New York City
n.d.

Beverly Sills
at a party for Jimmy Carter
Kennedy Center, Washington, D.C.
Wednesday, January 19th, 1977

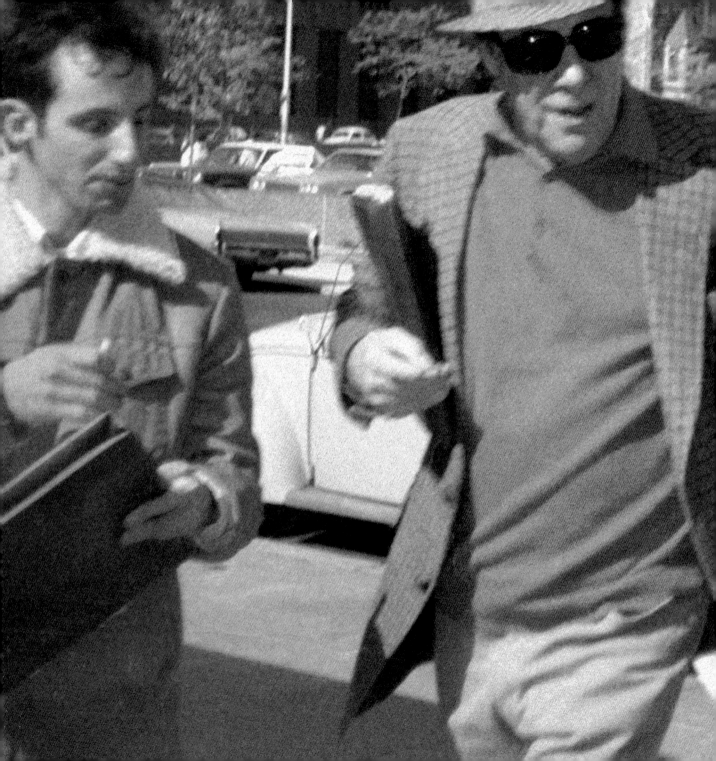

chance encounters

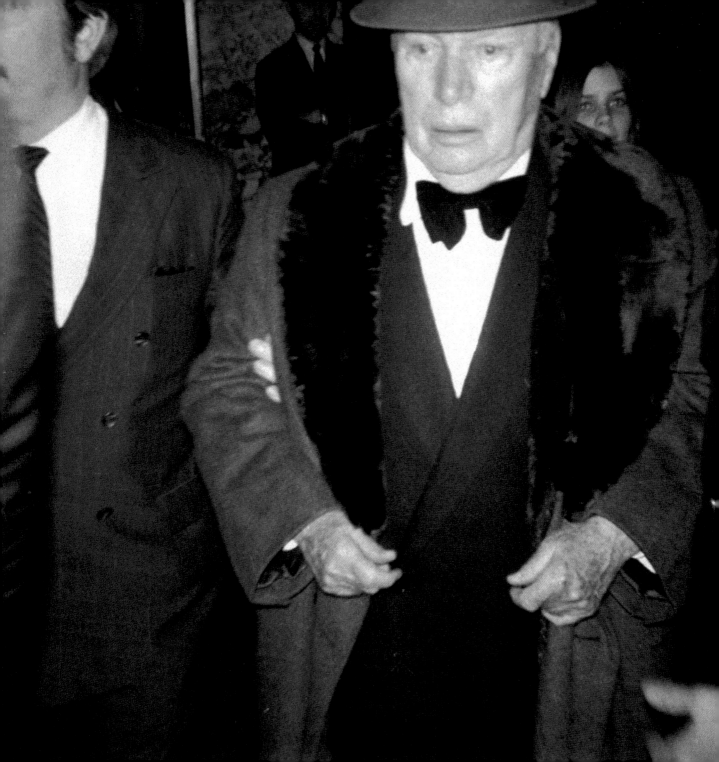

Charles Chaplin
at the Plaza Hotel
New York City
Tuesday, April 4th, 1972

I knew he was in New York because he was being honored at Lincoln Center, and then he was going out to L.A. to receive a special Oscar. I knew he lived in Switzerland and that he didn't come over here at all because he wasn't welcome for some political reason. There was a lot of hype about him coming to New York, but when I took this, I didn't realize it was a big deal, that I was getting a bite of history—all I knew was that this was an old actor who had made silent movies.

It was nuts at Lincoln Center. Everyone wanted something out of the poor old man, me included. I got him later, and only because I was hanging out at the hotel he was staying at; I spent two days on and off at the Plaza Hotel waiting for him. I had to keep moving around because security was really tight, and there were two entrances. I knew he was going to lunch, probably at the 21 Club, so I knew he would have to leave the hotel between eleven and two or so.

I got him in the lobby when he was walking from the elevators. It was hard to get a clear shot of him because he had so many people guiding him—he would get disoriented very quickly. He had to sit down every thirty steps for two minutes, and I remember he had two canes, so he couldn't sign anything.

Back then I didn't know there were 8x10 still stores, so whatever I had clipping-wise was what I carried around to get signed—something out of a movie magazine or a newspaper or *Life* or the *Saturday Evening Post*. Unfortunately, because he hadn't been around, I didn't have any clippings of him. I had nothing except a 5x7 picture postcard and a blank index card. His wife Oona said she would take them up to the room to get them signed and it might take a day or so to get them back, but she'd do the best she could. And he did sign everything I had.

He died soon after I saw him. It's funny—at the time the picture almost seemed like a strain to even take, because, again, I was smitten by TV. I was no more excited waiting for him than I was for Richard Chamberlain. It was just the goal of that weekend, to get Chaplin. I had no idea I was waiting for a dying

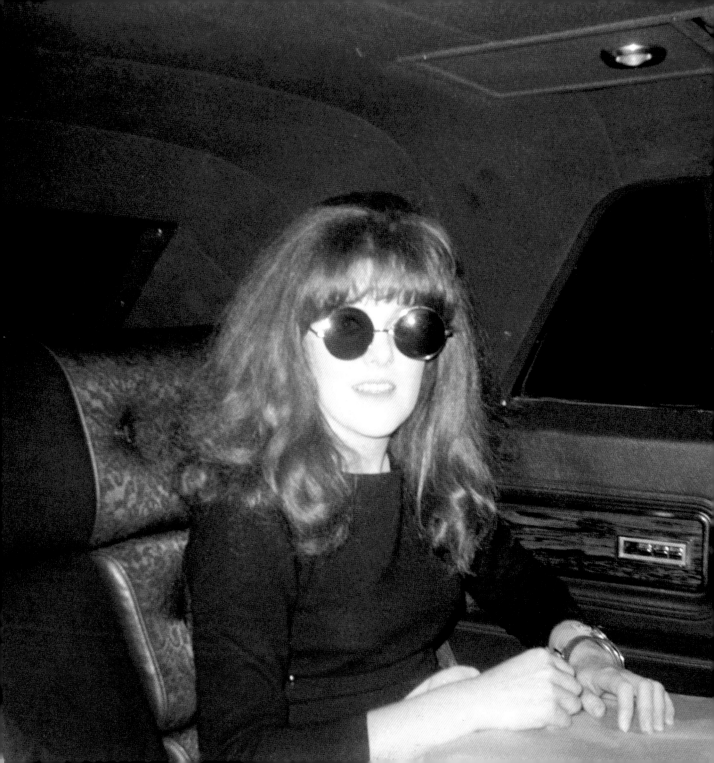

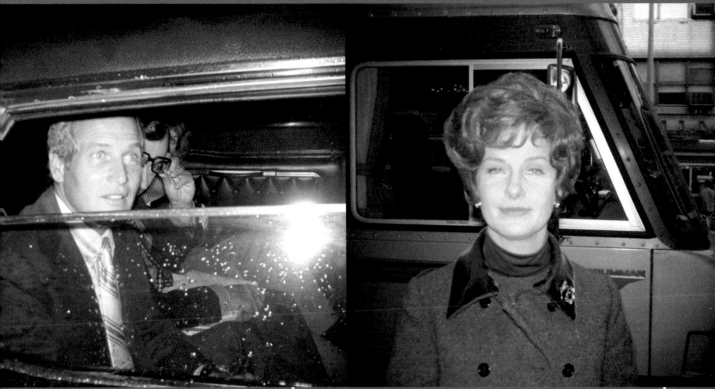

Paul Newman
in front of Sardi's restaurant
New York City
Saturday, April 22nd, 1972

Joanne Woodward
filming *The Death of the Snow Queen*
New York City
Wednesday, November 22nd, 1972

Lynn Redgrave
in front of the *Dick Cavett Show*
New York City
Wednesday, June 4th, 1969

Joan Fontaine
outside the Metropolitan Opera House
New York City
n.d.

Olivia de Havilland
at the Plaza Hotel
New York City
Saturday, November 18th, 1972

Butterfly McQueen
walking on 8th Avenue
New York City
Sunday, February 1st, 1970

Warren Beatty
in front of the Carlyle Hotel
New York City
Friday, June 16th, 1972

Art Garfunkel
in front of the Carlyle Hotel
New York City
Thursday, June 15th, 1972

Diane Keaton
on the street
New York City
Friday, June 16th, 1972

William Friedkin
at the *David Frost Show*
New York City
n.d.

Jeanne Moreau
on the street
New York City
n.d.

Elizabeth Montgomery and Robert Foxworth
at the *Tony Awards*
Shubert Theatre, New York City
Sunday, April 21st, 1974

I was at the Ethel Barrymore Theater, where they were throwing a 100th birthday party for Ethel Barrymore as if she were alive. All these old waxworks were there celebrating—people like Mirna Loy, etc. I had all my bags of books sitting in the corner of the lobby out of the way of everybody, waiting for it to end. This little Spanish usherette came up to me and we were going through who we had seen going in, and she said, "Oh there was this old man and he had a hearing aid... " and I had no idea who she was talking about and when the theater left out, she pointed to him, and she said, "That's him, that's him." Well I followed him halfway up the street, and I kept looking and thinking "I have no idea who it is," which is unusual for me. I'd left my bags back in the lobby—the usherette was watching them for me—and I thought, "Well, I'll get him to sign a card and I'll see who he is when he writes his name." So, I approached him, and when he wrote "Robert Montgomery", I freaked—I didn't even know he was alive and he was in every book that I'd had back in the lobby, because he was a big matinee idol, a big leading man in the 30's. I told him I had all these books back in the lobby, and he told me to go get them, and I ran back and got the books and he signed all twenty-some, standing there. I ignored everyone else there, and I didn't even care who I'd missed. If I'd have missed him, I'd have missed the biggest catch there is as far as I'm concerned, because I never saw him again. Never saw him before, never saw him again. And nobody ever brings him up. I've never heard anybody say "I've met Robert Montgomery."

Years later, there was a play opening in Los Angeles, and Elizabeth Montgomery had come to the premiere. We had all taken her picture and got her autograph, and she proceeded to walk up the street to go get into her car. Next thing you know, she comes back down the street towards us, and asked if somebody would come up and take a picture for her—she would pay him—and me and another guy went up. Here her father had gotten a star on the sidewalk on Vine Street, and she never even knew it; she was seeing it for the first time. So she kneeled down by the ground and posed with the star of her dad. She was just so thrilled—the whole time she was touching it, you know, making a connection. And it was touching, considering she had cancer and she was dying herself. I sent her the picture.

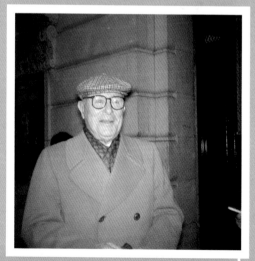

Robert Montgomery
outside the Ethel Barrymore Theatre
New York City
n.d.

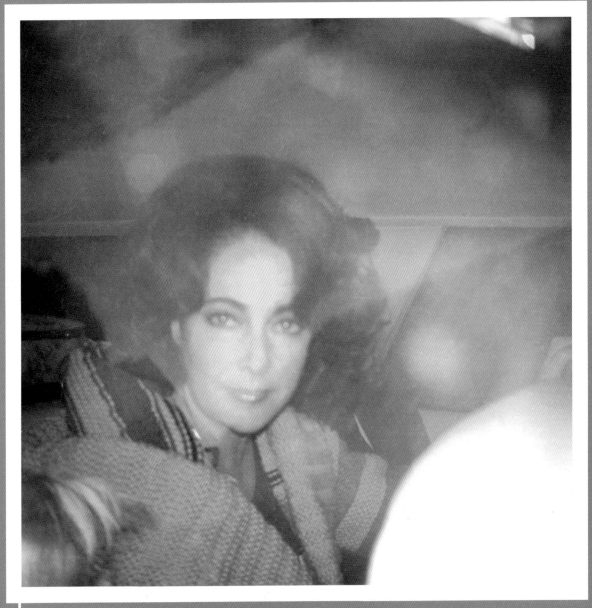

Elizabeth Taylor
at the Lombardy Hotel
New York City
Thursday, February 24th, 1976

Richard Burton
at the Lombardy Hotel
New York City
Saturday, May 18th, 1976

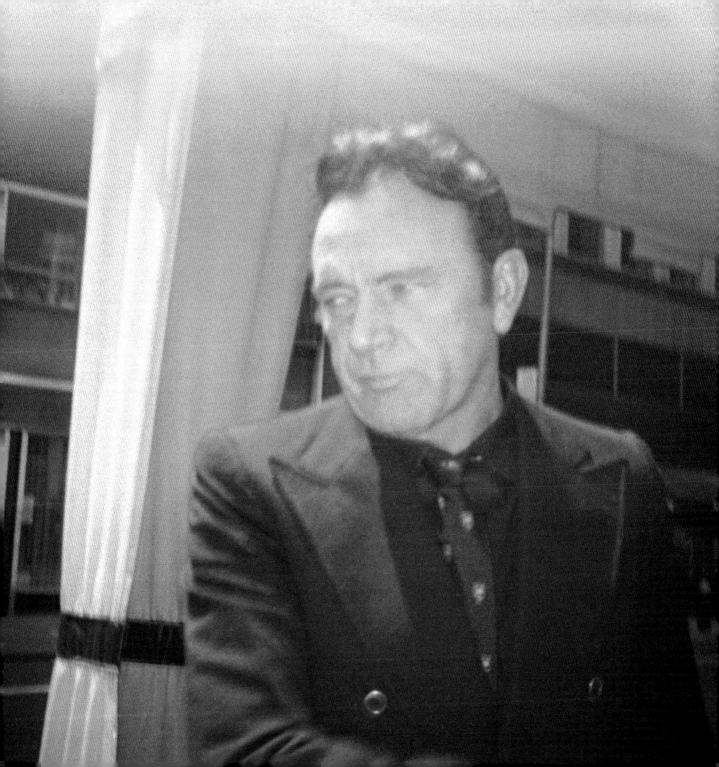

David Niven
at the *Dick Cavett Show*
New York City
Thursday, April 25th, 1972

Barbara Stanwyck
at the Plaza Hotel
New York City
Friday, September 25th, 1970

William Holden
on *Midday Live*
New York City
Monday, November 8th, 1976

Bette Davis
at the *Mike Douglas Show*
Philadelphia, PA
n.d.

Joan Crawford
in *A Night of Famous Women*
City Hall, New York City
n.d.

Cary Grant
at a Friar's Club roast for Frank Sinatra
Tuesday, February 24th, 1976

I was waiting in front of Halston's house one night because Liz Taylor and Liza Minnelli were in there partying. I'd followed them there from Studio 54 with my friend Jeff. I had this book of portraits of celebrities, and I had the Liz Taylor one ready to go when she came out. So Jeff and I were waiting, and all of a sudden—it must have been about three or four in the morning—this older woman and this very flamboyant guy, wearing, like, pink jeans, walked past us on the sidewalk. And as he walked by, Mr. Pink Jeans was eyeing up Jeff and I was eyeing up the old woman. Well, when she passed, I just felt like this was someone: she had sunglasses on, it was four in the morning... I told Jeff to wait there, and I started walking.

I took the book of portraits with me and followed them for two blocks. Then I crossed over to the other side of the street so I wouldn't look so obvious, but the whole time I'm looking, trying to find out, "Who is it? Who is it?" I came up with the possibility that it was Hedy Lamarr. I opened the book I was holding to her page, and as they started walking up to the steps of this brownstone, I darted across the street and I said, "Miss Lamarr, would you please sign this?" She looked over and said, "Oh, you're mistaken." Up close, I thought for sure it was her, but I left and went back to Halston's. So we're standing there five or ten more minutes, and who comes down the street but the flamboyant queen. Right away he stopped, and he said to me, "How'd you know that was Hedy Lamarr and then have a book with her picture in it?" I said, "I'm waiting here for Liz Taylor, and they're both in this book." Well, as soon as I said I was waiting for Liz Taylor, he just went crazy—you know, a queen and Liz Taylor... he literally dragged me to the corner and called Hedy Lamarr up on the telephone, and he proceeded to say, "You know that guy who approached you for an autograph? I'm down here right now talking to him, and he was waiting for Liz Taylor, and that's what he was standing there for." He ran the whole thing by her, and then he handed the phone to me. And I get on, and she apologized for not stopping, but said I scared her. Then she told the guy—her hairdresser—that one afternoon I could come over and she would sign what I had. So I went over one day with him; he had a key.

She was living on 64th Street in an apartment with only three rooms. There wasn't anything glamorous about it; it was just the small apartment of a broken-down actress who didn't work anymore. The furniture was sort of a mix and match of everything. Back in those days stars didn't get residuals, so if you didn't invest your money well, you had to live striving. That happened to a lot of stars from that era, like Veronica Lake—she died a waitress in the Village. Betty Hutton ended up washing dishes in a rectory. Hedy Lamarr was arrested three times for shoplifting. She lives in Florida now.

Ray Bolger
at the Americana Hotel
New York City
n.d.

Jack Haley
at the Sherry Netherland Hotel
New York City
n.d.

Margaret Hamilton
in *A Little Night Music*
Forrest Theatre, New York City
n.d.

Charo
at a party
Kennedy Center, Washington, D.C.
n.d.

Larry Hagman
on Broadway
New York City
n.d.

Telly Savalas
at the Americana Hotel
New York City
December, 1976

John Wayne
at the Pierce Hotel
New York City
Saturday, September 25th, 1976

Edna Thayer
in front of her apartment on 7th Avenue
New York City
Wednesday, March 12th, 1975

While we were staying in New York, my mother and I would get up Sunday and go to the Horn and Hardart Automat on Broadway in Times Square. It was a big cafeteria a whole block long. Horn and Hardart would have all different kinds of people. It drew the same sort of crowd that would hang out at a Woolworths—either that or the tourists. There was a big glass window that ran the whole way down the wall with little glass doors that you would pull aside once you put your money in. It was like a giant vending machine with people behind it constantly replacing the food.

The vaudeville era was long over, and there were people from the day who would come out and spend the day there with their friends. They were all older and out of work. And they had a little platform set up inside, and on certain days of the week they would set up a microphone. I don't think anything was even designated; it seemed like it was impromptu, like if they felt like it, these old vaudeville players would just get up on stage and do their thing.

I had no idea who Edna Thayer was at the time, but she seemed to stand out for some reason. Only later did I realize what a huge vaudeville star she was. At the time, I was sixteen and watching this very entertaining, very strange old woman with white pancake makeup and intensely bright pink blush and lipstick, very white hair and blue eyeshadow—and in those days they didn't chintz on the blue. It was cream and it was like blue lipstick on your eyelids.

The stage was set up right next to the large window, so you could see her performing when you were walking down the street. They had a bullhorn-style speaker that would boom her voice out to the sidewalk to draw people in. I just remember her singing in a really gutsy, raspy style—like after you've had a few gin and tonics—"When the Red Red Robin comes Bob Bob Bobbin' Along…"

It was sad, because she looked like the typical broken-down star—overexaggerated makeup with her fingernail paint half chipped off. But she had spunk. It seemed like people weren't performing for the money, they were just doing it for the love of it. Maybe Edna got a free cup of coffee, but I'm sure she wasn't getting paid for singing. None of them were.

Robert Morley
at the Plaza Hotel
New York City
Saturday, September 30th, 1978

Janet Gaynor
in *Harold and Maude*
Martin Beck Theatre, New York City
Saturday, February 9th, 1980

Bing Crosby
at a Broadway Show
New York City
n.d.

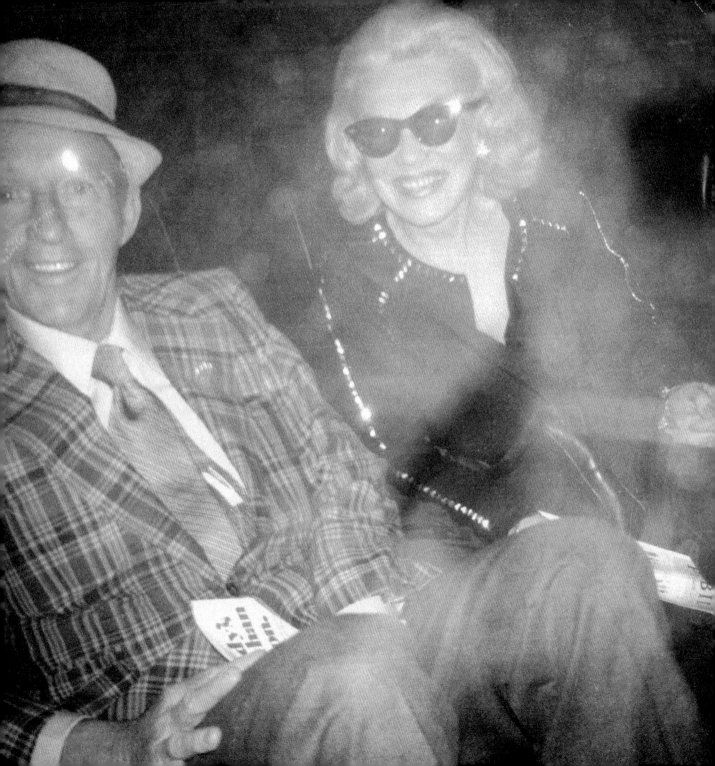

Bobby Riggs
eating at Wally's restaurant
New York City
Saturday, August 28th, 1976

Dr. Renee Richards
eating at Wally's restaurant
New York City
Saturday, August 28th, 1976

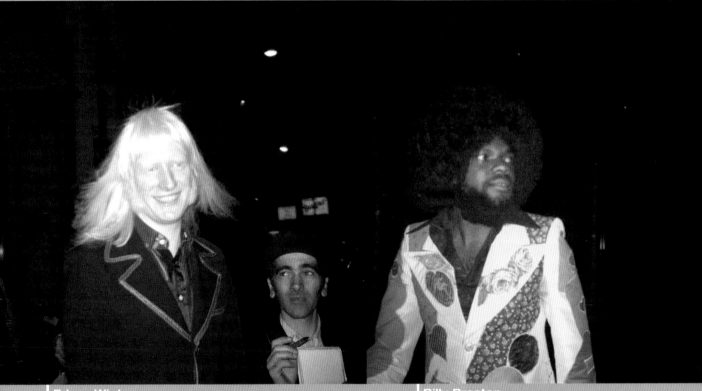

Edgar Winter
at the *Merv Griffin Show*
New York City
n.d.

Billy Preston
at the *Grammy Awards*
New York City
Saturday, March 1st, 1975

Aretha Franklin
at a party for Jimmy Carter
Kennedy Center, Washington, D.C.
Wednesday, January 19th, 1977

Greta Garbo
on 52nd Street near her home
New York City
Saturday, April 29th, 1978

I saw her five times, and this is the only photo I ever got. She had a personality like a cat. She could tell if somebody was around her, stalking her or noticing who she was. She would actually stand in front of store windows and watch reflections, and if she wanted to lose you she'd go into department stores and zigzag in and out. And she lost us that day. I knew she lived on 53rd Street and that she'd have to come home at some point. It was a dead-end street, so my friend Jeff and I waited up at the corner. I didn't want to admit to Jeff that I was nervous—not just because she was who she was, but because I was afraid she was gonna holler at me or hit me. So I talked him into standing in the phone booth on 53rd, and I was the lookout at the corner. When I saw her coming I was going to nod, and when she came around the corner he was going to jump out of the phone booth and snap her. And four hours later, that's what he did—only she noticed him first.

John Huston
directing *Independence*
Philadelphia, PA
Tuesday, June 24th, 1975

Bob Fosse and Jessica Lange
on the street
Key West, FL
Monday, April 3rd, 1978

Elliott Gould
in front of the Sherry Netherland Hotel
New York City
Saturday, February 21st, 1976

Donald Sutherland
in front of the Sherry Netherland Hotel
New York City
Wednesday, July 26th, 1978

Jan-Michael Vincent
filming *Defiance* on East 12th Street
New York City
Thursday, November 9th, 1978

Henry Winkler
at a telethon
Ed Sullivan Theatre, New York City
Saturday, January 31st, 1976

Sylvester Stallone
filming *Rocky II*
Philadelphia, PA
Tuesday, November 28th, 1978

Gary Boas with Frank Sinatra
at Jilly's restaurant
New York City
n.d.

249

Hanging outside specific restaurants and clubs was one of the best ways to get one-on-one encounters with certain people. You'd go around to each one, and the doorman would tell you who was around that night, and that's how you decided where you would stand and who you wanted or needed. The trouble was, you would have to stand for hours in front of one club just to wait and meet one person, *if* they came out, *if* they were cooperative, *if* you met them.

The first time I ran into Sinatra was at a restaurant called Jilly's that he used to hang out at. Somehow I found out he was in there with Jack Benny. My mother and I waited and waited, and it was almost four in the morning when they came out, and all of a sudden Jack Benny and Frank Sinatra were right in front of me. I knew who Jack Benny was because of television more than I knew how famous Frank Sinatra was. All I knew was that there was a big decision of who to get, and I couldn't get both in the way I wanted to get them just because of the hour of the morning and the whole rush after waiting so damn long. So I remember my mother got Jack Benny's autograph as I was getting my picture taken with Sinatra. And at the time I thought, "Oh shit, I missed Jack Benny for Frank Sinatra!" But any time I met Sinatra from that time on, it would have been virtually impossible for me to accomplish what I accomplished that night. You could never get to him. There were always so many people around him yanking Frank all over, trying to be "with the man," trying to be famous for a moment because he was so famous. You never knew who had the authority to push you away or who was just pushing you away because they were all about themselves, because they were in the inner circle, so it was very hard to get to Frank himself.

I guess now when I look at what I got, all of the waiting I did was worth it more than it wasn't. If I really think about all of the man-hours I spent in my life just waiting—it's more than I care to think, enough hours that I could go to high school again. There were so many hours of waiting. And there are certain points where you go over that line where you think, "Do I wait a little more? Do I give it up? I waited this long..." then it gets a little longer, then before you know it it becomes determination, because at least you want to walk away knowing. But there was always that possibility lingering that they would come out and blow you off in thirty seconds, and you've waited thirty hours. I dealt with that possibility all the time.

Mick Jagger
at the Pierre Hotel
New York City
Saturday, August 23rd, 1975

Keith Richards
seeing *Saturday Night Live*
NBC Building, New York City
Saturday, October 21st, 1978

Tom Jones
at a party for Lew Grade
Hilton Hotel, New York City
Sunday, April 18th, 1975

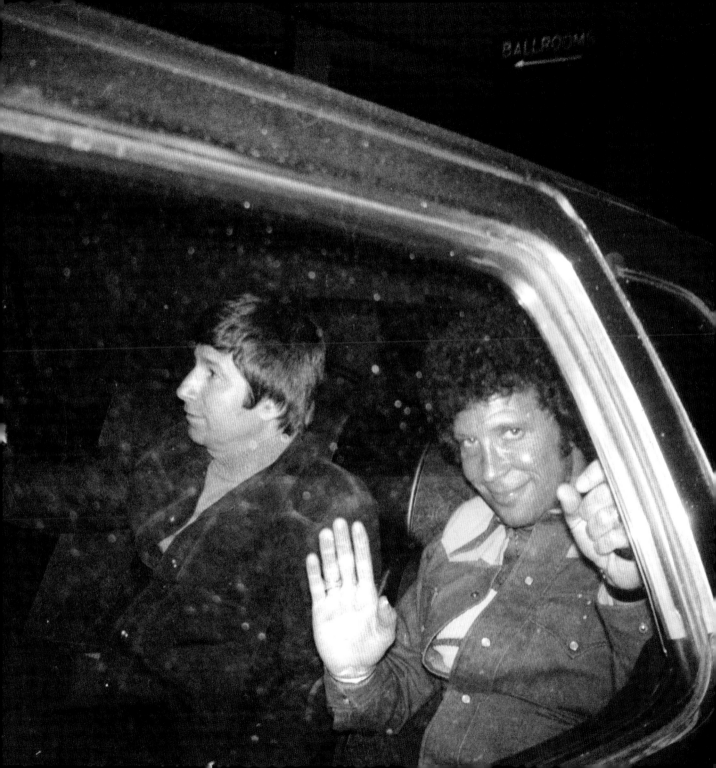

Harrison Ford
in front of the Sherry Netherland Hotel
New York City
n.d.

Carrie Fisher and Debbie Reynolds
at the play *Censored Scenes from King Kong*
Princess Theatre, New York City
Saturday, March 8th, 1980

Billy Dee Williams
on the street
New York City
n.d.

Mark Spitz
at the Holiday Inn
Philadelphia, PA
Sunday, March 3rd, 1974

Jim Kelly
at a tennis tournament
Madison Square Garden, New York City
Sunday, October 10th, 1976

Buster Crabbe
at the Hilton Hotel
New York City
Sunday, March 3rd, 1974

Joe Frazier
at the Americana Hotel
New York City
n.d.

Muhammad Ali
at Party City
Lancaster, PA
Saturday, October 6th, 1979

Al Pacino
at the American Film Institute
Kennedy Center, Washington, D.C.
Thursday, November 17th, 1977

Richard Gere
in *Bent*
Apollo Theatre, New York City
Saturday, December 15th, 1979

Sammy Davis, Jr.
at Wolf Trap National Park for the Performing Arts
Vienna, VA
Thursday, June 2nd, 1977

Barbra Streisand
at the premiere of *Funny Lady*
New York City
Tuesday, March 11th, 1975

Bill Murray
at *Saturday Night Live*
NBC building, New York City
Saturday, May 10th, 1980

Steve Martin
at *Saturday Night Live*
NBC building, New York City
Saturday, May 17th, 1980

Garrett Morris
at *Saturday Night Live*
NBC building, New York City
Saturday, December 15th, 1979

Gary Boas with Gilda Radner
in *Lunch Hour*
Ethel Barrymore Theatre, New York City
n.d.

Chevy Chase
at a reception for the
Robert F. Kennedy Tennis Tournament
NBC Building, New York City
Friday, August 25th, 1978

John Belushi
at the Sherry Netherland Hotel
New York City
Wednesday, July 26th, 1978

Randy Jones
from the band *The Village People*
Brunswick Hotel, Lancaster, PA
Thursday, August 17th, 1978

David Hodo and Glenn Hughes
from the band *The Village People*
Brunswick Hotel, Lancaster, PA
Thursday, August 17th, 1978

Chris Squire
from the band *Yes*
Millersville State College, Millersville, PA
Wednesday, July 26th, 1978

**politicians
pageants
and
porn stars**

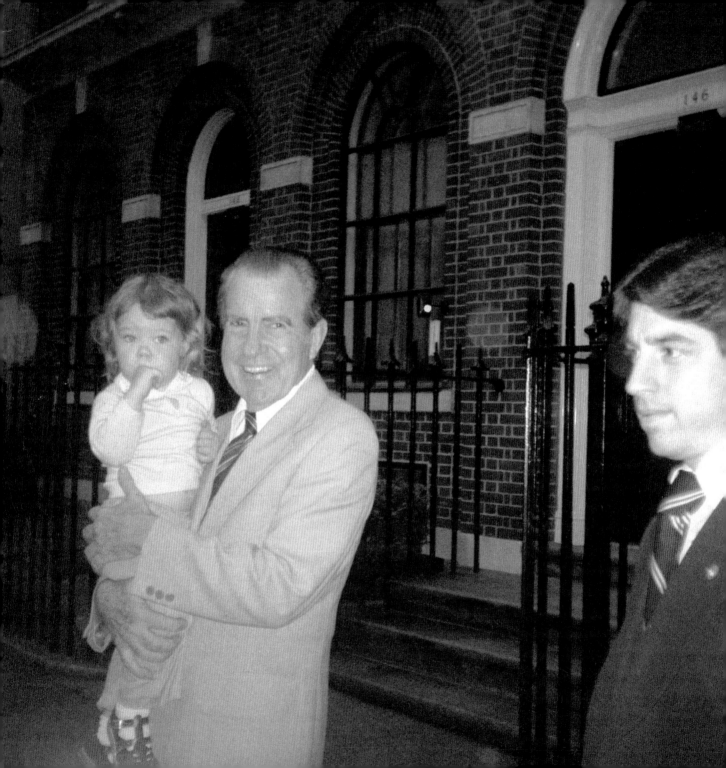

Richard Nixon and granddaughter
outside the Nixon house
New York City
n.d.

Nixon was very personable. I didn't know him before Watergate, and I don't know if life just brought him to this, but he was very tender. I waited outside of his house about twenty times. Mainly it was a combination of two things: first, he fascinated me. But also, every time I visited, I would leave and realize I forgot to have him sign something—that, and the fact that I wasn't supposed to like him, but I did. I was intrigued by him and the fact that he was so accessible.

He lived on East 64th Street in New York in a brownstone, and I soon realized it was very easy to wait for him to come out in the morning. Of course, he always had one or two Secret Service men with him, but he was approachable. I stood there one day and started learning his schedule. It was very predictable: he'd leave for work at 7:00 in the morning, come home at 3:30. I think the very first time I hung out so long, the Secret Service people got it in their heads that I wasn't a threat. And every time I turned around, I had something else that I thought of to have autographed: "Oh, I should have gotten him to sign this picture; Oh I should have gotten him to sign this book, Oh I should have..." so I had numerous reasons to go back numerous times. I always felt a very good rapport. There are certain people that you obviously connect with for some reason. Even today, I'll be talking to somebody and I'll feel their eyes floating around like they're patronizing me, and yet other people lock right in and give me every moment that they're getting from me.

He was a little out of it; I'm sure that whole Watergate thing broke him down, and I think he was sort of a lost soul, but he and I connected. And I hit him on a funny morning and really connected when... well, they had a sale on the memoirs of Richard Nixon, and the book was as thick as a Bible. It ended up in the bargain barrel at the bookstore, for like, five dollars a book, and I bought twenty of them, because I figured I'd give everyone in my family a signed book. They were so big to begin with that if you carried more than three it looked like you were carrying a library, so I kept going to his house different mornings at 7:00 with two or

Pat Nixon
in front of the Nixon house
New York City
n.d.

three of the books. Sometimes I hadn't even gone to bed yet because I had just left the discos, smelling not so pleasant, and I would go straight over to Nixon's in the same outfit I'd discoed in all night, sleep in my car for an hour or so in front of his house, and then get up and wait for him before he came out. After the second time I showed up with the books, he said, "How many of these do you got?" When I told him, he laughed. I said, "I'm giving them to my nieces and nephews as Christmas gifts." And he said, "Well thanks, but why don't you make it easier on you and me—my office is down in the Federal Building off Wall Street. You just put a piece of paper in each one and tell me who you want to dedicate it to and I'll get them all done in one shot." And I thought, well thanks, that does make it easy. So I took them down to his office. His secretary arm-wrestled me at first, but she went into his office and talked to him and came out and

Richard Nixon
Lancaster Airport
Lancaster, PA
Saturday, October 18th, 1970

said, "You're right, you are allowed to be here." I came back a few days later and each book was signed and dedicated and dated, with a special message written in each one. I made an effort to go back there and thank him, and that's how it all started—him being polite, and then us exchanging Christmas cards, and then me being invited into his house. They invited me in one day when it was cold and I'd been waiting outside a little while for him to come out. They must have seen me through the window. I waited in the foyer.

I was in Los Angeles when he passed away, and I got an invitation to the funeral. Needless to say, that was one of the most intense times of my life, because I was sitting in an audience amongst the greatest dignitaries of our times, like five living presidents in a row and their wives, four Secretaries of State... it was just a moment that I thought I would never, ever forget, because to be included in that crowd of people which was hand-picked, to sit at that funeral as a guest was just a situation that was unbelievable to me, like frozen time.

Julie Nixon
opening the Nixon Campaign Headquarters
Manor Shopping Center, Lancaster, PA
Wednesday, September 11th, 1968

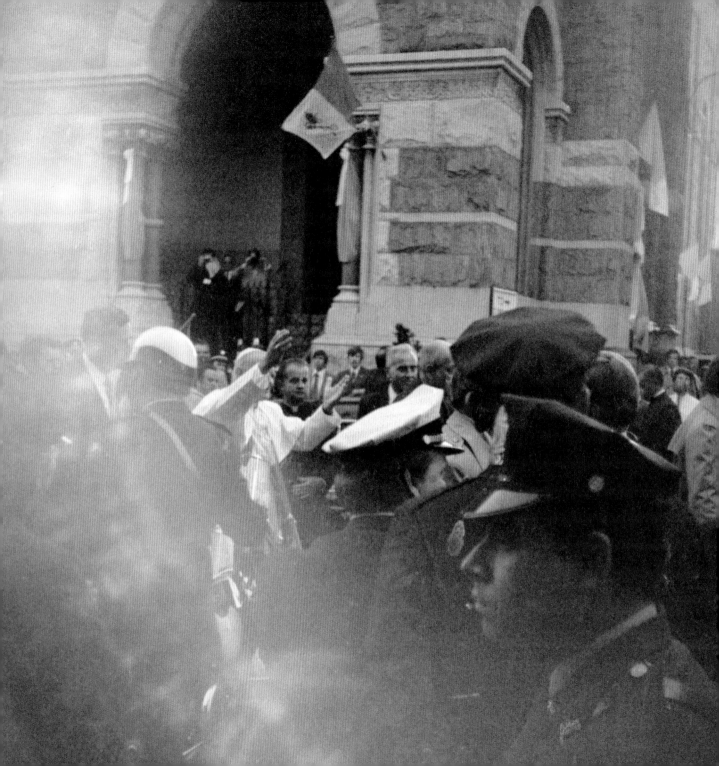

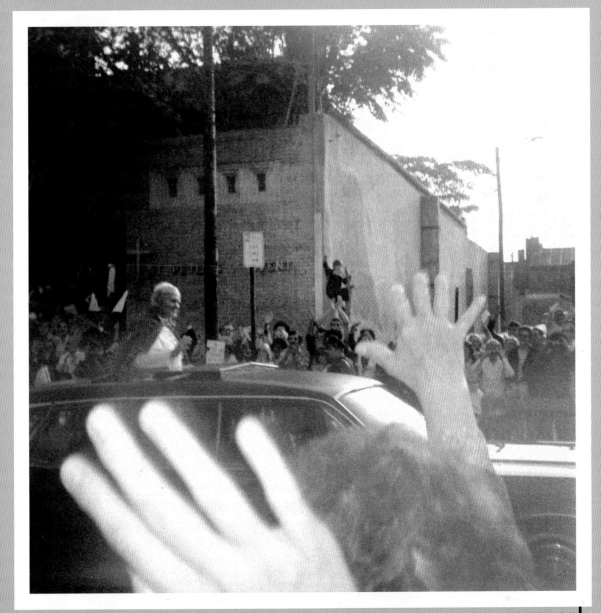

Pope John Paul II
Papal tour
Philadelphia, PA
Thursday, October 4th, 1979

Pope John Paul II
Papal tour
Philadelphia, PA
Thursday, October 4th, 1979

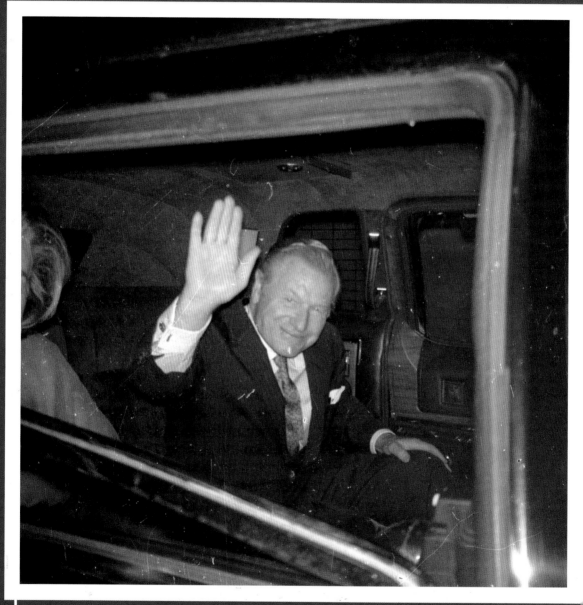

Nelson Rockefeller
at the Metropolitan Opera house
New York City
Sunday, May 9th, 1976

Marilyn Cham
New Yo
Wednesday, April 14

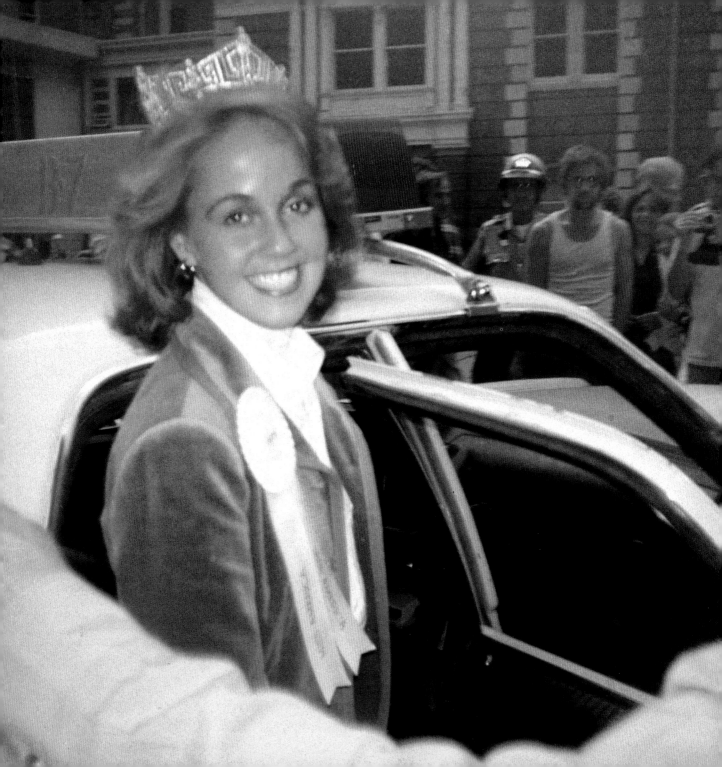

Bert Parks
at the *Miss America Pageant*
Atlantic City, NJ
Saturday, September 11th, 1976

Terry Meeuwsen: *Miss America 1973*
at a reception for the
Robert F. Kennedy Tennis Tournament
NBC Building, New York City
Friday, August 25th, 1978

Susan Perkins: *Miss America 1978*
at the *Miss America Pageant*
Atlantic City, NJ
Sunday, September 11th, 1977

**Gary Boas and Jeff Wieler
with Tina Thomas: *Miss Lancaster***
at Whatt and Shand Department Store
Lancaster, PA
Sunday, September 11th, 1977

Arnold Schwarzenegger
at the Americana Hotel
New York City
Saturday, August 27th, 1977

Ray Mentzer: *Mr. USA*
Lancaster, PA
Friday, June 15th, 1979

Gary Boas with Helen Madigan and Marc Stevens
Lancaster Bridge
Lancaster, PA
Sunday, January 9th, 1977

Marc Stevens and Helen Madigan were major porn stars back in the late sixties and seventies, especially Marc. He was known everywhere as "Mr. 10 1/2."

My friends lived in the Village, and they kept telling me about this porn star who lived across the street from them who would lie on his roof in the nude to suntan, but they didn't know who he was. One day I was down there and he was out on the roof, and as soon as I saw him I knew who he was, because I worked in a porn store. I looked in the phonebook and he was listed, so I called him up and I told him I had a few things I'd like him to autograph—that I had friends who lived across the street, and the next time I came to New York, was it alright if I stopped by. He was very flattered and very friendly. So later I went over and he signed my things, and he was just extremely gracious and something just clicked. We became friends, and he basically opened the door to the porn world for me. He was a very interesting, outgoing person.

Helen Madigan was his friend at the time, like Annie Sprinkle was for a while. I got to know him so well that he and Helen came down to Lancaster—they decided they just wanted to get out of New York City for a while, and they were going to make a personal appearance at the local dirty bookstore that I was working at. They stayed with me and my mother while they were in town. I took them to Pinnacle Point, with the rocks and the lake, and I took them to Amish country, the whole thing. He was really sweet. He later married a transsexual—Jill Munroe—also a porno star. I heard they had a big porno wedding, got married in the nude. I would always visit him and hang out with him when I was in New York.

Harry Reems
at a party at Elaine's
New York City
Monday, November 15th, 1976

Geraldo Rivera
at the *Mike Douglas Show*
Philadelphia, PA
Wednesday, March 10th, 1976

Jane Fonda and Tom Hayden
at Three Mile Island nuclear power plant
Harrisburg, PA
n.d.

It was just a few months after the movie *The China Syndrome* came out that we had the possible meltdown situation at Three Mile Island. They were evacuating everybody in the whole area right up to Lancaster, which was twenty miles away—that was the cut-off point. And everybody in town was being given a choice on the news whether or not to leave: it was like, "If you want to leave, leave, because if this thing goes, they don't know what's going to happen." And it was a scary period because it was almost like a nuclear bomb was about to go off, and you had to decide, are you going to die? Are you going to glow in the dark, or what? It was weird to actually have to decide something like that and to think, how far do you go? How did they know that our town was the cutoff line?

Jane Fonda was so affected by this that she came to Lancaster after they got it under control and realized it wasn't going to melt down. There was a highway that goes right past Three Mile Island, and she went to every person's house on that highway and knocked on the door. I don't know what exactly she said when she was inside. I think she was trying to more or less comfort them and console them, being that, now you have to choose to live here and you don't know what effect this has had, and is it still happening? You don't know. But yet what are you going to do, get up and move because all of a sudden you're not sure? Is this ever going to happen again in your lifetime? I remember that these were her issues when she was talking to the news crew, and that's basically when I got the shot. And I got a few of her just walking down the highway. I never personally talked to her.

Whichever cause she was pumping at the time, she lived it to the hilt. I think whatever she hollered about was very valid, you know. She had a voice and she used it—and she jeopardized her stardom a lot of times by speaking with that voice. She was just totally compassionate, warm and sincere. And it was odd that, for some reason, she always came to Lancaster, of all places. When she was Hanoi Jane, she came and spoke at a local hippie function and at the Unitarian church. Now she is borderline unapproachable. She doesn't really act anymore, and it seems the days of stardom are unimportant to her. If she does come out, it's usually for a cause, and she'll just go for the press line. But she didn't ever really like to be the center of attention anyhow.

Three Mile Island nuclear reactor
Harrisburg, PA
Sunday, November 7th, 1976

Gary Boas with Ronald Reagan
at the Landis Valley Motor Inn
Lancaster, PA
Sunday, June 12th, 1979

I met Reagan at the Landis Valley Motor Inn in Lancaster. He was ex-governor at the time, running for president, and he was there for some sort of luncheon. He definitely had security with him.

Because he was in politics and didn't really associate with Hollywood stuff anymore, I was the only actual fan who was there to see him that day. I brought four friends, and each friend had five of my books. I gave them instructions at the side of the building: I told them to just do the walking and I'd do the talking. Most of the time it was difficult bringing anyone along with me because they didn't have the patience to wait for the kill, and I always walked away with the gain. I made sure I had the five best books in my hand just in case something happened.

There were four of us, and the minute he started walking forward I sort of stepped in front of him and asked him if he'd please sign my books, and he said sure. His security guy said, "We're running a little late." I had the book of Westerns at the top; it was the one I most wanted him to sign because I had one page in there that was already signed by John Wayne, Henry Fonda, and Jimmy Stewart. He looked at the signatures and said, "How can I say no when you've already got these guys?" And he started signing. I had a system where I had all five books opened to the place where I wanted him to sign. (A lot of people didn't mind signing several things when they realized it was a hobby.)

So then he finished my books and continued on to sign the books my friends had. Suddenly, all of my friends froze—they were speechless in front of him and they lost all sense of assertion, so I literally grabbed the books out of their hands, and as soon as he signed each one, I laid it in a pile on the ground. I was hitting the twenty mark of things for him to sign before anybody even asked "How many more do you have?"

The Collector

by Carlo McCormick

There is nothing quite like a memento. As intuitive as Gary Boas's creative process has been, he certainly has understood the potency and attraction of the keepsake. We all hold onto something as a reminder of a person or event. Souvenirs accumulate, in time, like memories, not so much vague as faded and dusty. They become talismanic icons of where we have been, in physical and personal space. Token representations of what we have seen, they fail in veracity of fact and experience alike. Until, that is, they serve as triggers for memory. Some collect T-shirts, and there are those who save their love letters, but nothing has served the needs of keepsake better and more commonly than the photograph. This is fundamentally what made Boas a photographer. The passion and commitment with which Boas has hunted and collected these visual trophies, and the intensity with which he fixes them in the gaze of memory, make him a much more fascinating photographer than the contemporary paparazzi. It is, however, the way his compulsion manifests the deeper desires and darker needs of our society that makes his extensive body of work so relevant to, and resonant with, the issues of contemporary photography. Boas's extremely candid camera grabs its subjects in a way that's very much in keeping with a new generation of photographers who have abandoned the notion that one exactly perfect moment exists for every picture and who have begun to revisit and re-evaluate "imperfect" interstitial moments. Boas appeals not only to this shift in style and heightened appreciation for the amateur snapshot, but also to our obsession with nostalgia, which is being reluctantly guided by our hunger for authenticity.

Celebrity has so consumed our private imaginations and occupied a pervasive, long-standing place in our public consciousness that just thinking about it seems redundant. In the firmament of fame, the star shines so brightly and with such scope that we hardly ever consider how its visibility connects it to our own realm of experience. Boas's fanatical pursuit of the elusive star is in this way a provocative kind of visionary astronomy—through the lens or looking glass, it offers a pure distillation of our inherent voyeurism. His unrelenting photographic engagement with his subjects collapses the critical distance between the fantasy of representation and the actuality of presentation. His will to witness first hand and to acquire some tangible receipt of this exchange not only obviates the

psychological illusion of otherworldly separateness and exception that keeps the notable aloft, but it takes the passivity of viewership right off the couch and into the trenches.

Even when he may not have known exactly who he was looking for, the sheer voraciousness of his looking transforms Boas's photography into a kind of conceptualized and performative guerrilla action. The lengths he goes to in trying to capture the extremely rare specimen, like Greta Garbo, benignly mimics the way we as a culture stalk celebrity. And yet, while some stars, like Garbo, may be more treasured, none could be done without. In the lens-eye of Gary Boas, as in our communal gaze, a startling equivalence is granted to all manner of notoriety, regardless of context or degree.

Boas clearly set out to capture the famous, without regard for how or why stardom was bestowed. And the phenomenal thoroughness of Boas's guerilla star collecting results in endlessly enjoyable juxtapositions of personality. There is only one common denominator between the likes of Richard Nixon, Redd Fox, Frank Zappa, Mason Reese, Gloria Vanderbilt, and Cassius Clay, and that is fame itself.

The stars populating Boas's pictures take on the practiced poses and coded gestures of the public personae as they navigate social space. Running a media gauntlet or trapped in unsuspecting confrontations, these disembodied icons of celebrity perform acts of retreat, surrender, glamour, largess, and even hostility as they face the fate of recognition. This mass archive of images, correspondence and autographs, meticulously catalogued by Gary Boas over the past four decades, constitutes a lexicon of popular culture. Collectively, they trace the shifting whims of consumer appetite as well as the more complex evolutions in that subtle dance between the object of desire and its audience. We can see here not only the fadish changes in what people care about, but also how these attentions are expressed and received. In trying to capture personalities, Boas of course has caught much more. He's documented the full litany of expressions, spontaneous or rehearsed, welcoming, wary or wounded, candid or candied.

Ultimately Boas's work delivers the far more intangible evidences of time itself, offering up pocket pictures of a more innocent age when access was far less restricted or mediated, when heroes and heroines were not yet so hounded by the potential hostilities of fans and mass media. This sense of possibility, of direct intimate contact with an abstracted ideal, is as much what originally motivated Boas as what continues to make his work so compelling today. The amateur, everyday veneer of these episodic surveillances is as seductive as the antique quality of the pictures themselves. The pride taken in winning a trophy is one thing, but it is entirely another to marvel at some thirty-year-old trophy stripped of its original context. Today, to be honest, the aesthetic appeal of Boas's photographs springs largely from such nostalgic perversities. Similarly, at a certain point they stop being solely about the individuals featured and more immediately about the fetishism of fame.

————————————————————+————————————————————

At this terminal point in the century and millennium, our current fixation on the archival is certainly understandable. Dwelling in the long shadows of recent history, we cannot help but view Boas within the mannerist, romantic, nostalgic, and decadent aesthetics particular to this or any other fin-de-siècle age. The appeal of this work is as much its recollective powers as the way it represents Boas's mania for preservation. The waning impact of the twentieth century on our imagination will clearly diminish the part of Boas's work that passes through the eye of history. Certainly, it's hard to imagine how a figure like Bobby Riggs will translate outside the camp and irony inherent in the postmodernist morbidity of the present. And maybe his rare sighting of a red scare-exiled Charlie Chaplin back in the United States will not carry the same emotive impact on the other side of Y2K. But as a Who's Who of what we once noticed in the fluid whims of public interest, this detailed chronicle of celebrity is as symptomatic of the time it records as its current memorabilic allure is endemic to this moment. It's no coincidence that the arc of Boas's extensive project pretty much follows the path of cultural retrospection. He began to treasure the passing moment just as a whole epoch of immense invention was being replaced by narcissistic novelty, and just as popular culture turned its head from

looking forward to backwards. Boas's vision attains its greatest conceptual significance and aesthetic impact now, at the creative culmination of hindsight.

Beginning in the sixties, when the Pop project first catalogued a transcendent and transgressive iconography of fame, and drawing extensively from the seventies, not only an awesome repository of kitsch but the seminal model for the revivalism and redundancies of the contemporary entertainment industry, these pictures have all the preciousness of the reliquary artifact and convoluted exoticism of the found object. Verifiable records of deities from the rarefied realm of mass media alit upon the mundane corners of the everyday, their visages are redolent of the same veneer of authenticity so valued in our tabloid-tainted sensibilities. The beauty of Boas's art is it's seamless convergence of the extraordinary and quotidian; its matter-of-fact description of modern mythology. Arriving at a point when amateurism and casual snap shot aesthetics are being pillaged and mimicked in contemporary photography, from fashion to fine art, the discovery of these photographs now cannot be separated from the ongoing search for authentic and idiosyncratic representation. Reality-based TV, the archaic revivals of folk, amateur porn, documentary vérité and the cultural celebration of Outsider Art do as much to feed this need as they do for corrupting the very terms of realness they cherish.

The quintessential outsider, Boas possesses an archetypal otherness that goes beyond the self-taught and obsessive qualities of his art. His own sense of social difference stands in for all the inadequacies and awe we assume before the in-crowd. Strung out on the artifice of pop, he culls artifacts from the pursuit of fame which transmogrify the idol into icon, the illusion into art. Boas's photographs are not just real, but real dated and real weird in relation to the homogenized surface gloss of today's media machine. Creating his own private world out of public spectacle and wrestling some fact out of the fantasy of movie-star make-believe, Boas's rapid fire snaps fall outside all the conventions and constructs by which photography has always falsely framed its representations as reality. In doing so they achieve something quite remarkable and subversive—a semblance of what we might call, for lack of a better term, the truth.

index

Dilettante Press would like to thank the following people for their contributions and support:

Special thanks to:
Julia-Carr Bayler
Jefferson Holt
Steve Mirkin
John & Ellen Nalepa
Douglas Woods

Thanks to:
A&I Digital
Charlie Ackerman
Les Blank
Margaret Bodell & Les Bridges
Peter Burns
Cheryl and John Clegg
Kelly Cutrone
Dana Desmond
Distributed Art Publishers
Cheryl Dunn
Kamil El Kholti
Peter Friedman
Gordon Goff
Raul Goff
Eleanor Gossling
Cindy Greer
Marjorie Gulker
Jennifer Gross
Hennessey + Ingalls
Rebecca Hill
Matt Humphries
Dottie Katchmar
Sara Kenney
Duncan Laurie
Roger Manley
Carlo McCormick

META
Chris Miller
Blythe Millington
Michael Musto
Jan Nathan
Matt Neth
Bernard Neiman
Charlette Para
Adam Parfrey
Betty Patterson
Christy and Kevin Plaugher
Palace Press
Paul Prokop
Publisher's Marketing Association
Sir Robert Rader
Bill Rosendahl
Dr. Ben Rubenstein
Susannah Rubenstein
Theresa Saso
Larry Schubert
Jenny Sweitzer
Nick Weir-Williams
Madeline Wille
Walter and Nancy Wille
Allegra Yust
Jody Zellen

Production Notes

All photos scanned by Paul Tokarski at A&I Digital (L.A.) from the original color negatives.

Digital restoration by Nick Rubenstein, assisted by Matt Neth.

All story text edited from interviews with Gary Boas by Jodi Wille

Key layout assistance by Jody Zellen

Section head photo credits